# RICH MAN, BEGGAR MAN, INDIAN CHIEF:

## Fascinating Scots in Canada and America

## Tom Bryan

For Ivy – friend and writer
With thanks and warm wishes.

**Thistle**Press

Tom Bryan
Kelso
January 2007

Text © Tom Bryan, 1997
Illustrations © Suzanne Gyseman, 1997

British Library Cataloguing-in-Progress Data
A catalogue record for this book is available
from the British Library

ISBN 0-9520950-4-1

Published 1997 by
Thistle*Press*,
Insch, Aberdeenshire,
AB52 6JR, Scotland.

Printed and Bound in the U.K. by
Bookcraft Ltd

# CONTENTS

# INTRODUCTION

There are said to be over 40 million people claiming Scots ancestry on the North American Continent. Scottish influences on Canadian and American history, language and culture are simply too numerous to list in any one book. Yet, many of the colourful Scots who contributed to North American life have been forgotten, their lives neglected. The names of Bell, Carnegie and John Paul Jones may be well-known but there are countless others who deserve recognition and fame; in some cases, notoriety. These men and women were explorers, scientists, cowboys - and Indians. Some gave their names to rivers and mountains, others simply got on with living in a strange, often hostile environment.

This book is not meant to be a detailed study or complete list. It hopes to rekindle an interest in some of these remarkable individuals who would easily inspire poems, plays and songs about their lives. (Playwrights in particular may wish to explore this biographical goldmine further). Once the appetite is whetted, it's hoped the reader will then explore more of these lives through just some of the sources listed. Scots, Canadians and Americans should all be interested in this book which joins their histories together.

**TOM BRYAN** is a published poet and fiction writer who was born in Manitoba, Canada into a Scots family and has also lived in America. He is long-resident in Scotland, living in Strathkanaird, Wester Ross. He is married with two children. He has written many articles about emigration and given talks on Radio Scotland on the same theme.

ACKNOWLEDGEMENTS: ILLUSTRATIONS BY SUZANNE GYSEMAN, KILTARLITY, INVERNESS-SHIRE.

FRONT COVER: CHIEF WILLIAM MCINTOSH, CREEK CHIEF, CIRCA 1820. COLOUR PLATE FROM 'THE INDIAN TRIBES OF NORTH AMERICA' BY THOMAS L. MCKENNEY AND JAMES HALL, PUBLISHED BY JOHN GRANT, EDINBURGH, 1934. (There are several earlier editions of this book)

# I. POLITICS

# JAMES AITKEN

*Born. Edinburgh, Midlothian, 1752.*
*Died. By hanging, Portsmouth, England, 1777.*

**Known as "John the Painter". Whitesmith, highway robber, pirate, revolutionary arsonist; said to have been at the "Boston Tea Party". Was executed at the age of 25.**

Aitken, the son of a whitesmith (painter) was born in Edinburgh. Unemployed, he went to London and became a thief and robber on Finchley Common. Aitken was a republican and fled to America where he took part in the "Boston Tea Party". He hoped to further American and Scottish revolutionary aims by destroying the shipping and shipping yards of England during the colonial revolution.

He invented slow-burning incendiary devices which could be planted in the shipyards thus enabling him to escape hours before the fire took place. He made an unsuccessful attempt to burn the great hemp yard at Portsmouth but did succeed in destroying the rope house there. He next attacked the yard at Bristol. Attempting to burn the city itself, Aitken managed to burn seven quay warehouses. He was arrested and tried in Winchester, 6 March 1777 under the names of "James Hill", "James Hind", "James Actzen" on the evidence of another painter named Baldwin who knew Aitken in America.

Aitken was hung three days later, and left to hang at the harbour entrance of Portsmouth to discourage other would-be arsonists. His ghost was said to have visited the judge on the night of the execution. Many ballads and stories were inspired by "John the Painter's" tragic tale. In any case, this is a remarkable story and still has great possibilities as a play or opera. It has a very modern ring to it.

# JAMES ALEXANDER

*Born. Stirlingshire, 1691.*
*Died. Albany, New York, 1756.*

**Politician and statesman, defender of the freedom of the press.**

Alexander was born heir to the title of Earl of Stirling. He was a mathematician and engineer, taking part in the Rebellion of 1715. He fled to America, taking up residence in New Jersey as a practising lawyer. Alexander attacked corruption and consequently, made many enemies among the Colonial administration. He refused bribes and was often accused by his enemies of trying to incite the American colonies to rebellion. However, Alexander's fame rests almost entirely with one famous legal case which was possibly the most important in American legal history. James Alexander defended Peter Zenger, a printer and publisher whose newspaper satirised the Governor of New Jersey and his political allies. Zenger was charged with libel and sedition, and his newspapers were ordered to be burned by the public hangman. A local magistrate refused to allow this to happen but Zenger was jailed. Alexander defended Zenger with every means at his disposal but was himself accused of contempt of court and was struck off the roll of attorneys, depriving Alexander of his livelihood. Alexander Hamilton, another Scot, continued the case and obtained a verdict in favour of Zenger and his right to publish his opinions. James Alexander was reinstated, continuing his struggle against corruption in high places.

James Alexander was considered the greatest lawyer of his day in America. He corresponded with many great scientists and helped found the American Philosophical Society. His only son, William Alexander (later known as Lord Stirling) was a prominent general in the American Revolution.

# SIR JOHN A. MACDONALD

*Born. Glasgow, Lanarkshire, 1815.*
*Died. Canada, 1891.*

**The first Canadian Prime Minister, "Father of Confederation."**

Macdonald was born in Glasgow to a family with crofting connections to Rogart, Sutherland. He emigrated to Canada with his parents, later taking up the study of law and politics. He entered politics and soon became a leader of the Conservatives. He became Premier in 1857 and was Prime Minister when Canada became a nation in 1867. He was Prime Minister again from 1878 until his death in 1891.

Macdonald is credited with binding many of the elements together which helped Canada become a nation and maintain that status in its early years. He tried to combine his pro-British interests with ties to the French, the Americans and other interests. He tried to encourage Canada to strike a balance between its disparate parts, by encouraging strong units within a stronger whole, learning lessons from the American Civil War. Macdonald was also a pragmatic politician, always seeking solutions, always encouraging compromise and diplomacy. Macdonald hoped that westward Canadian development would bind the nation together and he gave every encouragement to the Canadian Pacific Railway.

Macdonald is considered the "father" of modern Canada. His is a name known to every Canadian school pupil. His achievement is commemorated by a memorial near his father and grandfather's croft at Rogart, Sutherland. Macdonald saw the young Canadian nation through many a crisis in its first years; many believe Canadian survival was only possible under John A. Macdonald - just the man the nation needed at that time.

# ALEXANDER MACKENZIE

*Born. Logierait, Perthshire, 1822.*
*Died. Toronto, Ontario, 1892.*

**Prime Minister "Sandy" Mackenzie refused a knighthood. Canada's first Liberal Prime Minister, champion of the common man.**

Most Canadians can name their first Prime Minister, John A. Macdonald from Glasgow, whose family came from Sutherland. Few can name their second Prime Minister - Alexander Mackenzie. Mackenzie was born in Logierait but grew up in Dunkeld and Pitlochry. His father was a carpenter. Mackenzie was a stonemason. Mackenzie emigrated to Canada in 1842, working as a stonemason in Ontario while campaigning quietly for liberal reforms in a Canada then controlled by a few wealthy families. Mackenzie gained a political reputation for being honest, predictable and somewhat boring. Canadian politics was rife with scandal and corruption which Mackenzie resisted. He became Prime Minister in 1873 and ruled until 1878, when John A. Macdonald gained power again with the Conservatives. Mackenzie was satirised mercilessly as gauche and backward, yet his government made many simple and lasting democratic reforms later taken for granted by all political parties.

Mackenzie never forgot his Scottish roots and returned often to Dunkeld, where he is remembered by a plaque at Number 9 Cathedral Street - where he lived as a boy. His name is misspelled there, something which would not have bothered this self-effacing man who refused a knighthood from Queen Victoria. He always preferred to be called simply "Sandy" Mackenzie. His honesty changed Canadian politics for the better; that legacy of integrity was probably his true achievement.

# WILLIAM LYON MACKENZIE

*Born. Dundee, Angus, 1793.*
*Died. Canada, 1862.*

**The scourge of Canadian wealth and privilege, this fiery politician once called Queen Victoria "Victoria Guelph the bloody queen of England." He tried to establish a Canadian republic by armed rebellion.**

Mackenzie emigrated to Canada in 1820, and began almost at once (in speech and print) to attack the wealthy conservative families who controlled and dominated Canadian political life. He became a radical MP for York District, but was expelled so many times from Parliament that the government refused to let him stand again for election. He continued to advocate republican reforms and was elected mayor of Toronto. The Tories were returned to power in 1836 and Mackenzie began to prepare for armed rebellion. He worked closely with the French Canadian Papineau to achieve his goals. Mackenzie hoped to rouse the masses to rebellion but instead had to flee Canada with a price on his head.

In Buffalo, New York, just across the Canadian border, he gathered an "army" (some would say a "rabble") and seized a small island while conducting armed raids against the Canadian government. He was imprisoned in America but was later extradited to Canada. On his return to freedom and politics, he continued to work for radical reform, despite many attempts to bribe or silence him. Mackenzie never toned down his attacks on the monarchy, in a country where republicanism had never been popular.

Mackenzie's place in Canadian history is uncertain. Some of the reforms he advocated came about naturally in the course of time. Many Canadians were suspicious of ideas which seemed too "American" or too radical for Canada's future. However, in one sense, Mackenzie had the final word because it was his own grandson, William Lyon Mackenzie King (1874-1950) who, as Liberal Prime Minister of Canada, continued the reforms Mackenzie advocated nearly 100 years before. His grandson certainly had an easier time of it!

# DAVID BRYDIE MITCHELL

*Born. Muthill, Perthshire, 1766.*
*Died. Georgia, 1837.*

**Mitchell County, Georgia is named for him; the town of Camilla, for his daughter.**

David Mitchell went to Georgia as a teenager and later entered politics, becoming a state representative and governor. He forbade duelling in Georgia and initiated many internal improvements in the young state: education, road building, frontier defence. He sadly foresaw the conflict between white settlers and the Creek Indian nation but tried to prevent bloodshed between them.

Mitchell was respected by all those who knew him and was made an Indian agent to the Creek nation, helping negotiate an important treaty with them in 1818 which added greatly to Georgia's land.

He ended his political career with charges of scandal against him; charges which were never proved. The state legislature of Georgia acknowledged his services by erecting a marble tomb to his memory. He was a key figure in Georgia's development as a state.

# ALLAN PINKERTON

*Born. Glasgow, Lanarkshire, 1819.*
*Died. Chicago, Illinois, 1884.*

**He founded the American Secret Service. We get the expression "private eye" from him and to this day, "pinkerton" is synonymous with "private detective" in America.**

Pinkerton emigrated to Chicago at the age of 23 and immediately gained a reputation as a tough crime-buster in that toughest of American cities. He stopped a major counterfeiting ring and halted extensive thefts from the railroads. He founded his famous and incorruptible Pinkerton Agency in 1852. He solved one of the great crimes of the day by capturing the men involved in the great Adams Express Company robbery of 1866.

Pinkerton also uncovered a plot to assassinate Lincoln and was in charge of Union spies during the American Civil War. Pinkerton is perhaps most famous for crushing the infamous "Molly Maguires" - a secret brotherhood who used intimidation and blackmail in the Pennsylvania coal fields. Pinkerton infiltrated this dangerous organisation with Irishmen of his own choosing, cracking the ring and bringing its ringleaders to justice.

Pinkerton risked his life many times and captured some of the roughest criminals of his day. However, many trade unions considered him merely a vicious strike-breaker.

How did this fearless detective meet his end? While out for his daily walk, he stumbled, bit his tongue and died of gangrene - an unlikely end for this plucky Glaswegian whose very name in America stands for quality crime-fighting.

# JAMES
# WILSON

*Born. Near St. Andrews, Fife, 1742.*
*Died. Pennsylvania, 1798.*

**One of the
two
Scottish-
born
signers of
the
American
Declaration
of Indepen-
dence.**

Wilson left University without a degree, studied accounting for a short time, then emigrated to New York, where he landed amid much political agitation. He taught Latin, then worked in law, becoming prosperous. Wilson gave serious thought and study to the extent of Parliamentary control over the American Colonies and concluded that Parliament had no legal control over Colonial affairs. Wilson circulated an important document to that effect and spoke cautiously for clarification of Colonial legal rights.

As relations between Britain and her Colonies deteriorated, Wilson came more to the view that outright independence was the only solution to the problem and he was one of three Pennsylvania delegates to the Constitutional Convention to vote for independence; he also continued to espouse many principles, though radical at the time, which became the basis for new American Constitutional law. However, Wilson also opposed the new constitution for Pennsylvania which made him very unpopular in that state. He did so because he thought it unworkable - "detestable" he called it. His home in Philadelphia was attacked by a mob. Wilson's later career included banking, land speculation, privateering and other commercial enterprises, as well as his legal career in Philadelphia.

Wilson was an able man in many fields but his fame rests with his signature on the Declaration of Independence; many also hail him as the "Father of the Constitution". Many scholars have also discovered many Scottish legal terms and precedents in the American Constitution and attribute these to Wilson as well. He later became a member of the United States Supreme Court and the first Professor of Law at the University of Pennsylvania. Wilson's influence on American Constitutional law was immense.

# JAMES 'TAMA JIM' WILSON

*Born. Ayrshire, 1836.*
*Died. Tama County, Iowa, 1920.*

**He rose from an Iowa farmer to become Secretary of Agriculture under three different US Presidents.**

James Wilson was born in Ayrshire but his family emigrated to America when he was in his teens. They settled in Tama County, Iowa, where Jim became a farmer and community leader, fighting for the rights of farmers. He was a key figure in the Iowa state legislature and continued his campaign to improve agriculture in the state. Wilson was elected to the American Congress, serving on most of the agricultural committees; he was respected as a shrewd and able parliamentarian.

After his career in Washington, Wilson returned to Iowa to farm and write for farming journals. He was appointed professor of Agriculture at an experimental agricultural college and was one of the first to advocate the systematic study of agriculture on a scientific basis. Iowa State College (later, Iowa State University) became the model for later such colleges.

He became Secretary of Agriculture under Presidents McKinley, Roosevelt and Taft - a total of 16 years. He initiated most of the leading programmes which became the basis for agricultural policy in the United States including experimental agricultural colleges and stations, agricultural extension work, legislation dealing with cattle tuberculosis and plant and animal diseases and much, much more. He was also a pioneer in the area of soil and water conservation. He retired from his post in 1913, but continued farming to the end of his life.

"Tama Jim" Wilson was one of the great agricultural innovators in American history, having been given a solid farming background in Ayrshire.

# II. NATURALISTS: PLANT AND ANIMAL

# DAVID DOUGLAS

*Born. Scone, Perthshire, 1798.*
*Died. Hawaii, 1834.*

**Possibly
Scotland's
greatest
botanist.
He died
tragically.**

The only true native pine in Scotland is the lovely Scots Pine but the tallest and most majestic trees now found in Britain are here because of the courage of a stonemason's son. These stately trees, known as "Columbian" or "Oregon" pines in their native American Northwest are named for the man who introduced them to Britain, David Douglas.

Douglas was sent by the University of Glasgow to collect specimens and seeds. He collected no fewer than 8000 specimens of flora in California alone, and some of the loveliest trees and shrubs in Britain today were introduced from his collection, including the Noble Fir, the Red Silver Fir, the Beach Pine, the Sugar Pine, the flowering currant and countless others.

Douglas met a grisly death when he was gored to death by a wild bull in a deep pit in the Hawaiian Islands. Some claim he was deliberately murdered by being pushed into the pit. In any case, his early death at the age of 36 was a tragedy. Although a monument was erected by his colleagues in 1841 in his native Perthshire, perhaps the true living monument to this adventurous Scot is the tree which lives over 300 years and grows over 400 feet high, bearing his name.

# ALEXANDER GARDEN

*Born. Birse Parish, Aberdeenshire, 1730.*
*Died. London, England, 1791.*

**He studied the remarkable flora and fauna of the American Cherokee country. The flower, Gardenia, is named for him.**

Garden was a master of most of the sciences of the day, but decided medicine as a career. He emigrated to South Carolina, where he did much to halt smallpox amongst the colonists. He also later became a friend of the great American Quaker botanist, John Bartram. He corresponded with the great Swedish scientist, Linnaeus.

The animals and plants of America were considered so exotic that many European scientists refused to believe in them, but Garden continued to collect and study fish, reptiles, plants and amphibians and tried to communicate his findings to colleagues in Europe, despite their scepticism. He sent the first electric eel to Britain, causing a sensation by doing so.

Garden sided with the Crown during America's colonial struggles and had his property confiscated as a result. He also contracted tuberculosis but managed to carry on with his scientific studies. He hoped to publish a book about his adventures as a naturalist in the Carolinas but the papers and notes for the book vanished shortly before his death. Garden, who was said to be particularly fond "of refined female society" never forgave his son Alexander for supporting the American side during the Revolutionary War. John Ellis, the British naturalist, named the Gardenia in Garden's honour.

# PETER HENDERSON

*Born. Midlothian, 1822.*
*Died. New Jersey, 1890.*

**Horticulture expert, seed merchant, botanist. Was said to have written over 175,000 letters of gardening advice in his lifetime!**

Henderson arrived in New York City in 1843 with a few sovereigns in his pocket. He was to die with considerably more than that, for Henderson was to become the wealthiest seed merchant in history.

Henderson was the practical Scot who was far more interested in fruits and vegetables than ornamentals. He began by selling vegetable plants and greenhouses. By 1871, he had founded the great garden supply house - Peter Henderson and Company - which became a household name in America. Nearly every house in the nation had a seed catalogue from Henderson's.

Although he worked 16 hours a day in gardening throughout his life, he had time to become one of the most prolific gardening writers of all time. "Gardening for Profit" (1866), "Gardening for Pleasure" (1875) and his weighty "Handbook of Plants" (1881) are world gardening classics.

When Peter Henderson quit his job in an Edinburgh liquor store at the age of 15 and angrily walked out the door, he walked right into the history of popular horticulture.

# JOHN JEFFREY

*Born. Forneth, Perthshire, 1826.*
*Died. America, circa 1854.*

**This promising young botanist mysteriously vanished in America.**

Jeffrey began his botanical career as a gardener at the new Royal Botanic Gardens in Edinburgh. Jeffrey was selected by the Oregon Association - a group of men interested in gardens and botany - to go on a collecting expedition to the Pacific Northwest of Canada and America to secure seeds for large trees such as redwoods and firs for introduction into Scotland. Jeffrey was given training and all the scientific instruments he would need, with instructions on how to post his collections safely back to Edinburgh.

In 1851, he was in British Columbia, collecting around the Fraser River and Mount Baker. He sent many seeds and specimens back to Britain. In 1852, he was in what is now Oregon and Washington and sent off 5 packages of seed, but only two arrived in Edinburgh. His California collections were disappointing to his employers who had expected a lot more from him. His last consignment was sent in January of 1854, then he was never heard from again.

The Oregon Association sent a member, William Murray, out to interview him in San Francisco. Murray discovered that Jeffrey had never collected his letters at the British Consulate there. He never found John Jeffrey nor discovered his fate. There were many theories. Some thought Jeffrey had gone further into the south-western deserts and died from Indian or bandit attack or else died from thirst. Others claimed he had disappeared in the gold rush.

Jeffrey wasn't a failure. He introduced over a

hundred new plants into Britain while shifting the emphasis from gigantic trees to lovely shrubs and smaller plants. Some of his specimens still exist at Benmore Estate at Dunoon. He was highly thought of by his fellow botanists: he had a tree named after him - Pinus jeffreyi - the Jeffrey Pine which grows well in Scotland.

John Jeffrey's mystery will probably never be solved.

# JOHN JOHNSTON

*Born. New Galloway, Kirkcudbrightshire, 1791.*
*Died. Geneva, New York, 1880.*

**"Whatever I know about farming I learned from my grand-father."**

Young Johnston tended sheep on the Galloway hillside and there learned many of his most important agricultural lessons. He emigrated to New York state and began to farm 112 acres near the eastern end of Seneca Lake, near Geneva. The land prospered and because it was not originally very fertile land, Johnston's reputation as a farmer spread.

He once said his grandfather's favourite remark was: "verily, all the earth needs draining" and he tried to apply Scottish draining methods to New York soil, with great success. He introduced the idea of draining tiles to America and was roundly ridiculed for it: "John Johnston is gone crazy - he's buryin crockery in the ground!"

Yet, clearly, his drainage methods resulted in much better yields and before long, there was a great demand throughout America for Johnston's tiles, which he had begun to make by machine. He popularised other methods too: lime and plaster, manure, compost, oil meal for cattle and sheep, and the earlier cutting of hay.

Johnston was visited by farmers from all over America to see how his methods of farming rough hill ground could be applied to their own farms. His pithy sayings appeared in all the farm journals of the day.

Johnston was well-liked and respected. He raised and educated a large family. Johnston worked his farm until he was 87, dying in his 90th year. Simply, he used Scottish hill-farming methods for American hill-farming and they worked.

# JOHN MCLAREN

*Born. Stirling, 1846.*
*Died. California, 1943.*

**His daily struggle with California sand dunes resulted in San Francisco's magnificent Golden Gate Park.**

McLaren was born on a farm near Stirling and worked as a dairyman before becoming a landscape gardener. He worked at several fine estates including work in the Royal Botanic Gardens in Edinburgh. He went to San Francisco at the age of 23 and worked on various estate gardens along the California coast. He became an expert at reclaiming dune areas by means of sea bent grasses. In 1887, he was appointed Superintendent of Parks in San Francisco and took over a failed project to convert the sand dunes around the city into park land.

He began his campaign by insisting all the manure from horses in San Francisco be brought daily to the park. He insisted that trees planted from seed were more efficient than transplants; some were planted as much as six feet deep. He experimented with different trees and shrubs but finally established an effective windbreak against the sea.

McLaren won against the wind and sea in the end but had to defend his park from many encroachments. He detested public statues cluttering up his park and prevented a streetcar line from going through the park by transplanting huge trees overnight in the middle of the proposed route. A shortage of water was defeated by means of wells and windmills to pump water to the park. McLaren also developed forty-five smaller parks throughout the city, each bearing the stamp of his gardening vision.

McLaren won many honours throughout his long

life; the Stanford University Botanic Garden was his vision. His specialty was in growing huge shrubs and trees from seed in record time. McLaren was also somehow able to transplant huge trees successfully.

The magnificent Golden Gate Park in San Francisco will be his lasting testament; won from the sea by McLaren's vision and tenacity.

# ARCHIBALD MENZIES

*Born. Weims, Perthshire, 1754.*
*Died. London, England, 1842.*

**The greatest of all Scotland's many great botanists.**

Menzies worked at the Royal Botanic Garden in Edinburgh and later trained as a surgeon in that city. He made his first botanical tour in the Highlands in 1778, then became a naval surgeon. His first major voyage in 1786 took him as far as China; next he visited Africa, New Zealand and the Northwest Coast of North America. He was naturalist and surgeon on board Captain George Vancouver's ship, "Discovery." Menzies was praised for his skills as a surgeon but also managed to do much exploring and plant collecting on his travels.

Menzies brought back many plants for Kew Gardens and is credited with introducing successfully many hundreds of shrubs, trees and grasses which now feature in most Botanical Gardens in Britain. He was elected to most of the leading scientific societies of his day and bequeathed an entire herbarium to the Edinburgh Botanical Gardens.

Although he introduced many plants to Britain from all over the world, the strangest and most distinctive is probably the Chilean Pine - the "Monkey Puzzle" - which is a feature of most older gardens in Britain. It was said Menzies saved the seeds of this plant rather than eating them for an offered dessert on a sea voyage. The seeds survived and all trees in this country stem from those original seeds. The scientific name of the plant bears his name.

Archibald Menzies continued his career as a surgeon in London and was buried in Kensal Green, London, in 1842 after an illustrious life. Many consider him the true "father" of Scottish botany and plant collecting; certainly, he was one of the pioneers in that field.

# JOHN MUIR

*Born. Dunbar, East Lothian, 1838.*
*Died. Los Angeles, California, 1914.*

**"The Father of the Environmental Movement."**

Muir emigrated with his family to the Wisconsin wilderness and worked at a variety of jobs, trades and inventions, losing an eye in an industrial accident in 1867. He always loved roaming in wild places and later farmed successfully in California. He rambled all over the Yosemite area (he called it "tramping") and soon developed a great love for the wilderness, which even then was threatened by unbridled forestry and mining. Early on, Muir saw the need to create places protected from greed and profit and saw a national park system as one way to protect America's wild places.

He studied the geology and wildlife of Yosemite and the Sierra Nevada - arguing, lecturing, writing in its defence. He lobbied in the face of power and corruption, but often won by sheer stubbornness. Muir wrote many classic books on his life as a conservationist which helped establish the whole conservation movement in America and indeed, in the rest of the world.

Nor was Muir an impractical romantic. He worked as a harvester, sheep shearer and wrangler all over California, taking to the foothills for months at a time. John Muir's legacy is immense. He is hero to millions worldwide, particularly in North America. His name appears all over the western map: on glaciers, lakes, trails, stands of trees (he loved the majestic redwoods). In Scotland, he has a 1700 acre country park named for him as well as the conservation trust, The John Muir Trust, established in 1984.

In some ways, Muir was far ahead of his time -

a bearded visionary and prophet of wild places. Muir once declared that "wilderness was a necessity." Muir once invented a clock that also lit the kindling for the morning fire but his true genius was kindling our awareness of our need for wilderness and our need to respect and preserve it.

It took many years for Muir to be as appreciated in Scotland as he is in the rest of the globe but his house in Dunbar is now a museum.

# WILLIAM SAUNDERS

*Born. St. Andrews, Fife, 1822.*
*Died. Washington, D.C., 1900.*

**Horti-culturalist, landscape gardener, pioneer in the intro-duction of foreign plants into America.**

Saunders came from a family of gardeners and was trained at Edinburgh. He began to publish articles in the leading horticulture journals, meanwhile becoming a leading landscape gardener, designing estates and cemeteries all over America.

He came to Washington D.C. in 1862 and designed many leading gardens and conservatories. He introduced many of the lovely trees seen along the famous Mall in Washington; it became the most comprehensive arboretum of its day. He was also active for the new Department of Agriculture, introducing the eucalyptus tree into California as well as many varieties of Russian apples and Japanese satsuma oranges which greatly improved the American citrus industry.

He helped found the important Patrons of Husbandry which sought to improve the horticultural situation in isolated rural areas; in keeping with this outreach idea, he published the first bulletin of the Department of Agriculture as well as over a thousand other titles, all intended to bring the latest plant knowledge to farmers throughout America.

William Saunders was considered one of the great popular horticulturalists in American history as well as one of its leading landscape gardeners. Much of his fine work can still be seen, particularly in Washington, D.C.

# ROBERT
# TAYLOR

*Born. Hawick, Roxburgh, 1847.*
*Died. Nebraska, circa 1920.*

**Brought
Scottish
animal
husbandry
to the
Western
Mountains
and Great
Plains.**

Taylor emigrated to America as a teenager, first to Pennsylvania, then to California. He was one of the first to introduce proper sheep farming to Wyoming, now a leading area for wool production in the US. He began his flock with 600 sheep and was able to sell out and buy his own ranch, in Hall County, Nebraska.

By 1913, Taylor had over 75,000 acres in Nebraska, where he had 65,000 sheep and 3000 steers. He was one of the first farmers in that state to farm sheep in such a big way. He also introduced the Clydesdale to the west as well as many strains of cattle, including the Aberdeen Angus.

Sheep farming was not seen as a possibility in the Western states until men like Robert Taylor brought their expertise and knowledge from the Scottish Borders where men had long been used to farming in adverse conditions.

# GRANT THORBURN

*Born. Dalkeith, Midlothian, 1773.*
*Died. Connecticut, 1863.*

**His seed catalogues were in every American home, for generations.**

This son of a Dalkeith nail maker was a physical dwarf, feeble from birth; but his own political ideas weren't feeble, causing him to be termed a "suspicious" person by the authorities in Edinburgh. This made him liable for imprisonment or transportation to Australia. Thorburn believed in democracy and the rights of man and was opposed to monarchy; as a result, he was forced to emigrate rather than risk going to prison, where many of his friends were. He arrived in New York in 1794, setting up in the nail-making business like his father before him, until the invention of a nail-making machine made his business redundant. He then took up the sale of plants and seeds (about which he knew nothing). At the height of a typhoid epidemic in New York, Thorburn's wife died from the disease and his business failed. He ended up in debtors' prison for a time.

On his release, he tried the seed business again and this time his seed and seed catalogue business flourished. He became wealthy. He issued the first real seed catalogue in American history in 1812 - "The Gentleman and Gardener's Kalendar for the Middle States of North America."

Outside of business, Thorburn was also highly valued as an original thinker and character. He befriended the radical Thomas Paine. Thorburn's life inspired a novel by the Scot, John Galt. The novel, "Lawrie Todd", prompted Thorburn to adopt "Lawrie Todd" as his pen name.

The name Thorburn was a household name in America for at least another decade and many isolated farmhouses looked forward to the delivery of their annual seed catalogue from Thorburn's. Thorburn was garrulous, egotistical, free thinking, outspoken. This son of a Dalkeith nail-maker rose to the heights of fashionable New York society in a manner more remarkable than any amount of fiction written about him.

# III.  ARTISTS

# THE HART BROTHERS

*James MacDougal Hart.*
*Born. Paisley, Renfrewshire, 1828.*
*Died. Brooklyn, New York, 1901.*

*William Hart.*
*Born. Paisley, Renfrewshire, 1823.*
*Died. Brooklyn, New York, 1894.*

**Landscape and portrait painters.**

Said William of his brother: "Aye, James is a fair painter but he cannae paint a coo to save his life." The brothers were apprenticed to a carriage maker in Albany, New York, where their parents had emigrated from Paisley. Both boys painted in their spare time. William ran away to Michigan, but caught malaria and came back home to New York. He went to Scotland briefly but returned to America to open a studio. He painted many scenes in the unspoiled wilderness of the Upper Hudson and belonged to the famous "Hudson River School" of painters. His paintings were unusually fresh and primitive, in a style suited to the wilderness he loved.

James had studied in Europe but had developed his own style. His attention to detail (especially in barnyard scenes) prompted his brother's famous statement about painting cows.

These Scottish brothers, despite their lack of formal training, had a secure place in the history of American painting, managing to capture features of a disappearing New York state landscape that has since vanished forever.

# JOHN KANE

*Born. West Calder, Midlothian, 1860.*
*Died. Pittsburgh, Pennsylvania, 1934.*

**A one-legged Pittsburgh house painter who was called " the most significant painter America has produced during the past quarter-century. " (1938)**

John Kane was born to Galway immigrants in Scotland. Kane worked down the mines at the age of 10. Emigrating to America with his brother, Kane worked as a coal miner, steel worker and railroad labourer. He lost a leg in a railroad accident at the age of 31. After the death of a young son, Kane suffered a breakdown and disappeared for long periods of time, making his living as a steeplejack painter. He took up painting and drawing, often painting murals on boxcars. He tinted photographs and made calendars for people in the mining communities.

He limped into the Carnegie Institute in Pittsburgh with various paintings for exhibition which were rejected at first but his "Scene from the Scottish Highlands" was exhibited to much praise. Thereafter, he began to exhibit work at Harvard and the Museum of Modern Art. Several of his paintings were sold for vast sums and found their way into private collections.

Kane's story became an overnight sensation and was recorded from a dying John Kane as "Sky Hooks: The Autobiography of John Kane" published in 1938. Kane died of tuberculosis in 1934; by then, the Pittsburgh house painter was known for paintings which were remarkably fresh and vital; all this from a man who had never studied art or painting and had only attended school in Scotland for a few days before going down the coal pits.

# WILLIAM KEITH

*Born. Old Meldrum, Aberdeenshire, 1839.*
*Died. California, 1911.*

**Conserva-
tionist,
painter of
the
Californian
wilderness.**

It was once said of Keith that there was no mountain in California he hadn't painted. An exaggeration perhaps, but Keith is still acknowledged as the greatest Californian landscape painter. Keith was taken to America by his family, then went out to California on his own. He was employed by the Northern Pacific Railroad to paint the railway's progress; money saved from this work enabled Keith to study abroad. He returned to California, becoming good friends with that other great Scot, John Muir. Together, they tramped much of the area that is now Yosemite National Park.

Keith was a patient observer of nature and tried to capture every detail of colour and shade. His paintings of redwood trees are among the most lifelike ever done. Keith lived in Berkeley, not far from the University of California and his home there became an informal meeting place for writers, Scottish exiles and artists. His friend John Muir from Dunbar was often called "The Prophet of the Wilderness". Aptly, Keith was termed the "Prophet Painter."

He warned people, on canvas, that this wilderness might soon vanish. Much of it has changed, if not disappeared and Californians remain grateful to this Scotsman for recording much of their wild heritage before it vanished forever.

# ALEXANDER LAWSON

*Born. Lanarkshire, 1773.*
*Died. Philadelphia, Pennsylvania, 1846.*

**America's great engraver of wildlife.**

Young Alex Lawson learned the art of engraving by means of a pocket knife and a shiny half penny. Many Scots engravers emigrated to New York and Philadelphia at that time. Lawson became famous for his engravings of birds and seashells and was often called on to illustrate scientific texts.

He met the penniless Alexander Wilson from Paisley, who was then compiling his monumental nine-volume masterpiece on American birds. Wilson couldn't begin to afford Lawson's fees but Lawson offered to provide engravings for Wilson at the ridiculously low sum of less than a dollar a day - "for the honour of the auld country" - said Lawson. The rest is history. Wilson's book is a monumental work, made even more so by the work of one of the leading engravers of the day.

Lawson influenced engraving in America, contributing greatly to its development.

# DUNCAN PHYFE

*Born. Loch Fannich, Wester Ross, 1768.*
*Died. Brooklyn, New York, 1854.*

**The "American Chippendale" - America's finest furniture maker and designer.**

Phyfe (Fife) was born in an area where trees do not grow easily, yet he became one of the great furniture makers of all time. His family went to Albany, New York, where Duncan became an apprentice cabinet maker. He moved to New York, becoming a joiner and cabinet maker. His business prospered and he employed as many as 100 skilled workmen. In 1837, his firm became Duncan Phyfe and Sons.

At the height of his fame, it was argued that Phyfe even surpassed the great British cabinet makers. His furniture was classical but distinctive, owing a lot to his skills as a wood carver. He was one of the first to use mahogany and none ever surpassed his skill with that wood. His pre-1825 furniture is considered the finest ever made in America; he specialised in tables, chairs and sofas, while deploring the heavy and cumbersome furniture that came into vogue later.

Most critics agree his influence on American design and furniture making was immense; he was called "the last of the great Georgians" which included names like Chippendale, Hepplewhite, Adam and Sheraton - not bad for a lad from the bleak moorlands of the Northwest Highlands.

# ALEXANDER HAY RITCHIE

*Born. Glasgow, Lanarkshire, 1822.*
*Died. New Haven, Connecticut, 1895.*

**America's most famous engraver.**

Ritchie left for Canada in 1841, having studied drawing at Edinburgh under the famous Sir William Allan. By 1847, Ritchie was working as an engraver in New York City and was soon enjoying a prosperous trade. Many of his engravings were based on his own paintings. His painting "The Death of Lincoln" became an American classic. Most of Ritchie's prints were historical portraits or idealised depictions of events and scenes. He was equally skilled in mezzotint, etching and line engraving and his work was greatly in advance of the time.

Ritchie was called on to do national portraits as well as scenes depicting sixty people or more; he was one of the few engravers at the time who had the skills to do this type of work. One of his most famous works was "Authors of the United States" (1866) which shows Irving, Bryant, Cooper, Poe and other New England writers - based on the original painting by Thomas Hicks. Most of Ritchie's work was so much in the American mainstream that many were surprised to know of his Scottish origins.

Alexander Hay Ritchie is certainly acknowledged as one of the most skilled engravers in American history.

# WALTER SHIRLAW

*Born. Paisley, Renfrewshire, 1838.*
*Died. Madrid, Spain, 1909.*

**Portrait painter, muralist and engraver - America's leading painter of murals.**

Shirlaw's father was a Paisley handloom weaver and inventor. His family emigrated to New York City where young Shirlaw became an apprentice engraver of banknotes. He learned painting in Chicago, then went to Munich to study. His most famous painting "Toning the Bell" was painted there.

He returned to New York in 1877 and became the founder and first President of the Society of American Artists. His first important mural was commissioned by Darius Mills; his second was "The Sciences" in the entrance pavilion of the Library of Congress in Washington, D.C.

He was one of a group who decorated a dome at the Columbian Exhibition in Chicago in 1893. He worked in stained glass and was also a leading illustrator for the major magazines of his day. He had become a famous designer, painter, teacher and muralist. He died in Madrid and was buried in the English cemetery in that city. His pictures are held in most of the leading American art galleries; quite a few of them are now privately owned, including his most famous work, "Toning the Bell."

# JAMES SMILLIE

*Born. Edinburgh, Midlothian, 1807.*
*Died. New York State, 1885.*

**America's leading landscape engraver; his engravings were in nearly every house in America in the 1850's.**

James Smillie's father was an authority of the fauna and flora of the Hebrides as well as a leading lapidary. James Smillie was apprenticed to an Edinburgh silver-engraver and later, worked for a steel engraver. James went to Quebec, working for his father and brother as an engraver in the jewellery business. He went on his own to New York, working as a banknote engraver. At this time, he began to produce some engravings of local landscapes.

Smillie began to produce works based on paintings. His large plates of "The Voyage of Life" by Thomas Cole became very popular as did his engravings for gift books and annuals. Another one of his famous pieces was based on Albert Bierstadt's panorama of the Rocky Mountains.

By 1861, he was back engraving banknotes but would always be remembered as a landscape engraver. He was one of the very few engravers ever elected to the National Academy of Design. Three of his four sons became important engravers as well.

James Smillie remains one of the masters of American landscape engraving; a craft he learned in Edinburgh.

# RUSSELL SMITH

*Born. Glasgow, Lanarkshire, 1812.*
*Died. Pennsylvania, 1896.*

**America's foremost scene painter for theatre and opera.**

Smith was born into a radical political family in Glasgow who were forced to emigrate because of their republican views. They settled in Pittsburgh. His father was a precision instrument maker; his mother, a physician. Smith began by painting portraits and scenery for a local drama group. He learned the art of scenery painting from James Reid Lambdin and embarked on a successful career in that field, painting scenes for opera and theatre in most of the major east coast cities.

He painted panoramas and dioramas, but continued doing drop curtains and stage scenery for most of the major opera houses in America. Some of these canvases were over fifty feet square or more, yet Smith insisted on doing all the painting himself, treating this work as an artistic expression of one individual; this notion was counter to the ideas of the time.

Smith somehow found the time to paint for scientists and geologists and did many illustrations for scientific books; he also painted landscapes in oils. Always, he was in demand all over America as a painter of drop curtains and stage scenery. He was an acknowledged master of a very specialised craft and did much to promote the scene painter as artist in his own right.

# WILLIAM PATERSON TURNBULL

Born. Fala, Midlothian, 1830.
Died. Philadelphia, Pennsylvania, 1871.

Turnbull was born in Midlothian and educated at the Edinburgh High School. He was interested in birds from his earliest years and he published a volume on the birds of East Lothian, which showed remarkable attention to detail.

**He followed in the footsteps of his ornithologist hero, Alexander Wilson of Paisley.**

He emigrated to Philadelphia in 1851 and began his ornithology studies from there. Turnbull had a remarkable library which included as much information as he could gather about his hero, Alexander Wilson. This included many priceless letters and manuscripts. Turnbull's classic work was "Birds of East Pennsylvania and New Jersey", published in 1869. It was called "a model of patient and accurate research and thoughtful study."

Turnbull was a member of most of the leading American scientific societies of his day in a city renowned for great scientists. He was a very popular man, genial and friendly to all who knew him.

He had many traits in common with his Scottish hero Alexander Wilson. Both were great painters and ornithologists; both lived in Philadelphia; both had a major impact on bird study and painting in America; and tragically, both died young, before their best work could be done.

# ALEXANDER WILSON

*Born. Paisley, Renfrewshire, 1766.*
*Died. Philadelphia, Pennsylvania, 1813.*

**A Paisley weaver and poet who became the "Father of American Ornithology."**

Wilson might have been a great poet in his native city of Paisley but fate decreed otherwise. This weaver and itinerant packman began to write poetry and asked Robert Burns for advice on the matter. Like Burns, Wilson was a great admirer of the French Revolution and Rights of Man and decided to write a poem on these subjects. However, this poem angered a Paisley magistrate and Wilson was imprisoned, while his poems were publicly burned in Paisley. Now out of prison, Wilson decided emigration would be the safest prospect for a republican poet at a time when republicanism was considered a threat to the British state.

Wilson went to Delaware, totally penniless. He worked as a copperplate printer, weaver and pedlar. He later taught school. Wilson befriended the great Quaker naturalist, William Bartram. Bartram persuaded Wilson to draw birds and Wilson thus found his true calling. In 1804, Wilson began a walking tour for the purpose of sketching birds, sleeping rough in the wilderness while doing so. As a result, his now classic "American Ornithology" appeared in 1808, but had disappointing sales (the book is worth a fortune today). Wilson then travelled over much of the American frontier, compiling material for his next bird volumes. He even descended the Ohio River alone in an open skiff. He spent the Winter of 1812-13 completing the next six volumes of his major work. He worked feverishly on these works, dying of sheer exhaustion in 1813. He was buried in the old Swedish church cemetery in the city of Philadelphia. Paisley finally acknowledged their native son with a statue in

1876.

Wilson's work was praised by that other more famous bird painter, John James Audubon, yet many artists consider Wilson's the superior work.

Alexander Wilson's first writings were publicly burned. His last works are considered priceless masterpieces of natural history.

# IV.  NATIVE PEOPLES

# SIR ALEXANDER CUMING

*Born. Culter, Aberdeenshire, 1690.*
*Died. London, England, 1775.*

**Cuming: "Emperor of the Cherokee", "Crown King of Tennessee", alchemist, visionary, pauper.**

Until 1730, Cuming's life had been the usual one of a gentleman of leisure of the time. But a trading voyage to the Carolinas was to change all that. As a member of the Royal Society, he was at first more interested in collecting herbs and minerals than in politics, but having decided that the Cherokee could play an important part in British Imperial politics, Cuming chose to try win the unpredictable Cherokee Nation to the British cause.

Cuming began to appear before tribal leaders in full Highland dress, demanding at sword-point full allegiance to Britain. Amazingly, this ruse worked and the Cherokee proclaimed Cuming "Emperor of the Cherokee Nation" and "Crown King of Tennessee." He had the powers of a dictator.

Flushed with this extraordinary success, Cuming returned to London with some of his Cherokee followers, who solemnly presented King George II with several scalps as a token of loyalty. However, even whilst Cuming was showing his Cherokee brethren the sights of London, he was accused of defrauding the honest settlers of Carolina out of vast sums of money. Cuming could not refute this charge and turned to alchemy in the vain hope of raising the money. He also began to dabble in visionary schemes, one of which was to settle three million Jewish families from Europe in the Cherokee mountains, with Cuming as their leader!

In 1737, poor Cuming was sent to debtors' prison where he remained until 1765, when he was admitted to Charterhouse - the famous London poor house. To complete this personal tragedy, Cuming's only son and heir died an alcoholic vagrant in Whitechapel, thus ending the hereditary line of the "Emperor of the Cherokee." Cuming is not entirely forgotten; the town of Cuming, Georgia is named for him.

# ROBERT DICKSON

*Born. Dumfries, 1765.*
*Died. Michigan, 1823.*

**Trapper,
soldier,
interpreter,
friend of
the Sioux.**

Dickson emigrated to Canada near the end of the war between Britain and America. He began to trade with the Indians near Lake Huron. He gained influence with the Sioux nation and married To-to-Win, the sister of a great Sioux chief. Dickson's influence in the Upper Mississippi region was widespread and he established a powerful fur company: Robert Dickson and Company at Michilimakinac. Dickson had divided loyalties when war broke out again between the Americans and British in 1812 because his own trading region straddled the Canadian and US border as it stood at the time. However, he fought bravely for the British side.

Dickson was not just interested in material gain. He had a vision of an industrial settlement of white trappers and Indians at the site of Grand Forks, North Dakota, based on mutual friendship and co-operation. Robert Dickson played a major role in the history and settlement of Michigan, Wisconsin, and the Great Lakes generally. He was respected by both Indian and white, and his appointment as Indian Agent for all the tribes west of Lake Huron was a measure of the trust and respect he commanded: a man from Dumfries who understood the heart and mind of the Sioux Nation.

# ANDY
# HALL

*Born. Liddesdale, Roxburgh, 1848.*
*Died. By murder, Arizona, 1882.*

**Indian fighter, explorer, nicknamed "Daredevil Dick."**

Andy Hall was born in the Scottish borders and emigrated to Illinois, where he joined a wagon train that was attacked by Indians. Hall thus became a confirmed Indian fighter. He once boasted that he wore his hair so long in order to tempt attack by would-be scalpers.

Hall's real fame came later, as an explorer. We know that the Scotsman Tam Blake may have been one of the first men to sight the Grand Canyon in 1540; Hall joined John Wesley Powell's famous expedition to explore the Grand Canyon in the 1860's. The men endured hunger, thirst, and near drowning in their gruelling 111 day ordeal down the Colorado River. Only six of the 11 men completed the journey. Hall was one of them and by all accounts, thoroughly enjoyed the experience, proving to be the most reliable member of Powell's party.

Hall lived for adventure but also died for it. In August 1882, he tracked two payroll bandits into the foothills of the Arizona mountains. He was murdered by one of the two men, who shot Hall in the back, leaving him to die in the desert. The men were later captured. So popular was Andy Hall that a lynch mob took the two men from the local jail and hung them as proper revenge for his savage murder.

Andy Hall had become a heroic legend in the Wild West.

# ALEXANDER MCGILLIVRAY

*Born. Alabama, 1759.*
*Died. Florida, 1793.*

"half Spaniard, half Frenchman, half Scot - all scoundrel" or, "the greatest Creek Indian chief who ever lived."

These quotes summarise the man. He was a bundle of contradictions. The son of Lachlan McGillivray, a Scottish trader, and a half French, half Creek mother. He fought for the rights of his people but owned black slaves. He lived all his life in America but hated American encroachment on his territory. He commanded many hundreds of brave warriors but was not a good fighter himself.

Young Alexander was trained to be a merchant by his uncle Farquhar, but returned to his own people when his father returned to Scotland. Creek Indian lands were coveted by the French, Spanish, Americans and British so McGillivray had to use all his political skills and intrigue to keep his land intact. He supported the British during the Revolutionary War and thus had some of his territory confiscated by the victorious Americans. McGillivray hoped to unite with Spain and thus secure a type of United States of Indian tribes. However, McGillivray was forced into a treaty with George Washington, which he conducted with great pomp and display. He received a pension from the US Government while secretly conducting business with the Spanish. On the way back from a secret treaty with Spanish officials in New Orleans, he died from fever. He was buried with full Masonic rites. McGillivray might have been both a scoundrel and freedom fighter but it can't be denied that he tried to keep his tribe from becoming extinct. He was also prepared to use all tactics to prevent that from happening. In any case, he had often heard about Culloden from his father and uncle, and thus tried to prevent the same thing happening to his own people. His actions bought his tribe another generation of freedom, which they finally lost under less effective leadership than McGillivray's.

# WILLIAM
# MACINTOSH

*Born. Georgia, 1775.*
*Died. Georgia, 1825.*

**"He sold the graves of our ancestors."**

MacIntosh was the son of a Scotsman and a Creek Indian woman. He realistically believed that Creek survival depended on friendly relations with the new American nation. He fought with the Americans against the British in the War of 1812, and helped massacre nearly a thousand of his own people in the Battle of Horseshoe Bend. MacIntosh, meanwhile, had to try deal with continuing broken treaties and seizure of Creek lands. However, he acquiesced in turning over more land and became wealthy doing so. In 1824, the majority party of Creeks passed a tribal law which forbade the sale of Creek lands under penalty of death, but in 1825, MacIntosh sold even more land to the Americans.

The tribe passed a death sentence on William MacIntosh and he was shot to death as he tried to escape. It was ironic that a Creek chief named MacIntosh turned over tribal lands which another Indian chief named McGillivray had sought to protect a generation earlier.

MacIntosh's life illustrates that the Scottish influence in North America is full of contradictions.

# CHARLES MACKENZIE

*Born. Ferintosh, Easter Ross, circa 1778.*
*Died. Red River Settlement, Manitoba, 1855.*

**He was often reproached by his fur company employers for "going native" and being too sympathetic to the natives; he was thus refused promotion.**

Mackenzie entered the fur trade as a teenager and soon began trading in dangerous Indian country along the upper Missouri, when few white men were in the area. Mackenzie returned to the area several times as a trader and was completely at ease with the Indian way of life. He wore Indian dress, while learning Indian ways and customs which he found preferable to white ways. He was never promoted, probably because he advocated fair treatment of native peoples; he called fur company methods "cold and calculating" and believed fur companies should have extended credit for essential equipment and tools which the Indians needed. He wrote valuable journals on Indian hunting practices and customs and remained very devoted to his Indian wife. His historical journals were published in 1889-90 and are packed with details of life in the mountains. He wrote about the wildlife and flora of the western mountains and plains. He and his wife nursed the Lac Seul Indians through a smallpox epidemic in 1845; Mackenzie himself caught the disease but survived. He retired to the Red River settlement with his wife and son, dying there in 1855.

If Mackenzie had any "failings" in the eyes of his employers, it was his concern for the native peoples he traded with and made his living from. His journals are filled with admiration for their customs and ways.

# HUGH MONROE

*Born. Scotland, 1798.*
*Died. Two Medicine River, Alberta, 1892.*

**Scottish fur trapper who married into the Blackfeet Nation.**

Monroe came to the Canadian West in 1814 as a fur trapper with the Hudson's Bay Company. Monroe became fascinated with Indian languages and customs, teaching himself many Indian languages. He was especially interested in the Blackfeet, who were renowned for their pride and hostility to both whites and other tribes. Monroe learned their language and later married Chief Lone Walker's daughter, Sinopah.

Monroe lived the rest of his life with the Blackfeet as a free trapper and trader. He conducted various expeditions through the mountains and undertook work for the Hudson's Bay Company who had limited success in dealing with the Blackfeet as a general rule. Monroe's life and attitudes were unusual for his time, thus assuring him a unique role in Western history.

# SAMUEL MUIR

*Born. Washington, D.C., 1789.*
*Died. Galena, Illinois, 1832.*

**He fell in love with an Indian princess.**

Muir was the son of the Reverend James Muir, of Cumnock, Ayrshire. James Muir was a Presbyterian minister who settled in America in 1788. His son Samuel was sent back to Edinburgh to study medicine but returned to America in time to be appointed surgeon in the US Army. Sam Muir was a capable surgeon and seemed destined for a great career when he fell in love with the daughter of the chief of the Sac-Fox Indian tribe. He adopted the ways of the Fox Indians and became one of their leaders. He lived the life of an Indian for over a decade, when he decided to return to medicine, settling in Galena, Illinois.

In 1832, there was an epidemic of cholera in the United States Army and he volunteered his services in the fight against the disease. Muir saved many lives and was known for his compassion and skill. However, he himself caught the disease and died.

Muir, as we shall see, was just one Scot who was able to settle and live among native American peoples, siding with them in their struggles against outside oppression. Muir's humanity seemed to be a legacy from his minister father, who was widely known for his tolerance and honesty in his adopted town of Alexandria, Virginia. The elder Muir preached in that city until his death in 1820.

# JAMES 'SCOTTY' PHILIP

*Born. Auchness Farm, Dallas, Morayshire, 1858.*
*Died. South Dakota, circa 1910.*

**"The Buffalo King", the great Indian Crazy Horse's brother-in-law.**

Not all of the people who went to George Grant's Kansas colony were wastrels. Jamie Philip went there as a teenager, then left to pan for gold in the Black Hills. Philip had many adventures in the Wild West. Like thousands of others, Philip left the Black Hills "busted clean", taking up the life of a cowboy and rancher. Philip had a good first hand knowledge of the Sioux and Cheyenne and actually became a brother-in-law of the great Indian warrior, Crazy Horse. He had great sympathy for the plight of the American Indian and for the source of their culture, the American bison or buffalo, which had practically become extinct by the turn of the century.

Philip began to round up the remaining buffalo which he kept in an enclosure on his ranch near Pierre, South Dakota. He retained only pure-bred buffalo and soon established a good breeding herd. In 1906, he was given 3500 acres by the US Government for pasturing buffalo. This park soon became a major tourist attraction and Philip sold breeding pairs as well as developing herds for meat. Although other herds also survived, most of the pure bloodline for this nearly extinct animal came from Jamie Philip's original herd.

Philip wrote often about the sad fate of the American Indian, expressing the wish that they would survive on their own terms. He knew their way of life would vanish with the buffalo but he at least had the foresight to save those spectacular animals from extinction. His own life was more fanciful than fiction - a true swashbuckler who deserved the sobriquet of "The Buffalo King".

# HUGO REID

*Born. Cardross, Renfrewshire, 1810.*
*Died. Los Angeles, California, 1852.*

**Reid was a key figure in the early history of Spanish and American California. He married an Indian woman and fought for the rights of her people.**

Reid was born in Scotland and educated at Cambridge. He left Britain as a young man (some say after being jilted in love) and spent six years wandering in South America in search of gold. He settled in San Gabriel, California and married a native Indian woman named Dona Victoria in 1837. Reid soon became a citizen of Spanish California, and was one of its leading citizens when California achieved statehood.

Although his wife was from one of the leading local families, because of her race, Reid was once deprived of his legally-held lands. Hugo Reid's "Letters on the Los Angeles County Indians", written for the Los Angeles Star in 1852, became classics of their kind. Reid discussed Indian customs, laws, languages, food, sports, fables, etc. These letters were the first objective portrayal of the native peoples of California, who at that time were threatened with genocide. Reid thus did much to rouse sympathetic white people to the plight of the Indian. The letters had repercussions throughout the United States and did much to promote the better treatment of native peoples. Reid also convinced many people that native customs were neither barbarous nor primitive, but were remarkable in their wisdom and practicality.

Hugo Reid was fluent in Spanish and many other languages. He was nicknamed the "Scotch Paisano" - a "paisano" being any worthy Spanish-speaking person at the time. His role in the history of California was pivotal and was first fully acknowledged by a biography entitled "A Scotch Paisano" by Susanna Bryant Dakin, published by the University of California Press in 1939.

Reid was just one of many Scotsman who had great sympathy with the native peoples of North America. His writings helped promote their struggle for justice.

# JOHN ROSS

*Born. Lookout Mountain, Tennessee, 1790.*
*Died. Washington, D.C., 1866.*

**He was 3/4 Scots and leader of the Cherokee people for four decades. His Indian name was "Koos-eskowe" (White Bird).**

Many Cherokee and Creek Chiefs were part Scottish: MacIntosh, McGillivray, Ross and Grant. John Ross was the son of a Scottish trader, - David Ross - and a part Scottish Cherokee mother, Mary MacDonald. Ross was well-educated and fought with Andrew "Old Hickory" Jackson against the British in 1812. Ross opposed any attempts by the government to remove the Cherokee from their homelands to the western reservations. When he could no longer prevent these forced removals, he tried to smooth the way for Cherokee migration to Oklahoma. In 1839, Ross was chosen leader of the United Cherokee Nation. Ross had many critics from among his own people and was criticised for an aristocratic lifestyle which included the keeping of negro slaves. He tried to strike a balance between defending his people and securing the best deal for them in less-than-ideal circumstances. He often had to unite warring factions within the Cherokee nation itself.

Most historians see his forty years at the helm as proof of his skills as a leader. He sought neutrality in the American Civil War but was forced to side with the southern cause. He died in Washington D.C. while making yet another treaty for his people.

Many felt Ross deserved a better deal after the loyal support he gave the young American nation against the British in 1812. The harsh treatment of Ross and his people served as a warning to future Indian leaders. In many ways, the removal of the Cherokee people from their fertile homeland paralleled the Highland Clearances which drove men with the name of Ross, Grant, MacDonald, etc. to the Cherokee country in the first place.

# JOHN STUART

*Born. Scotland, circa 1700.*
*Died. Pensacola, Florida, 1779.*

**One of the first Superintendents for Indian Affairs.**

John Stuart was nearly fifty when he emigrated, becoming a soldier for the British against Spanish forces in what is now Florida. Stuart was familiar with the habits and customs of the Cherokees and was made Superintendent for Indian Affairs as a result of his experience with the native tribes of the South. He did much to conduct fair treaties with the Creeks and Cherokee, despite political pressures from the Colonies and Britain. Stuart was trusted by all and given complete powers to negotiate with the southern tribes.

He was accused of attempting to incite the Catawbas and Cherokee in the British interest against the Americans; he had to flee for his life while his wife and daughter were placed under house arrest in Charleston. They later escaped as well. Stuart continued to carry out his duties and helped put an end to rum smuggling into Mobile, Alabama. Many of Stuart's good activities on behalf of the Indians and colonists were interrupted by the American Revolution. He died while on duty in Pensacola, Florida.

In the face of bureaucratic interference and hostility , John Stuart still managed to conduct treaties and negotiations with the southern tribes which were fairer than most at that time.

# PETER
# 'INDIAN PETER'
# WILLIAMSON

*Born. Aboyne, Aberdeenshire, 1730.*
*Died. Edinburgh, Midlothian, 1799.*

**He wrote: "French and Indian cruelty exemplified in the Life and Various Vicissitudes of Peter Williamson ....with a Curious Discourse on Kidnapping."**

At the age of ten, Peter Williamson's adventures began in earnest when he was kidnapped from the streets of Aberdeen and sold into slavery in America, a common and lucrative practice at the time. His own master (in Pennsylvania) was a Scot, who freed Peter at age 17. Williamson worked his own land from which he was captured by marauding Indians who were allies of the French in their wars against the British for control of North America. He escaped and became a soldier, suffering many more misadventures in the process; a serious wound allowed him to be discharged from the army. He survived and went back home to Aberdeen, eighteen years after his original kidnapping; however, he was immediately banished from his native city because his allegations about kidnapping in the city were an indictment of many prominent and influential persons who had made money from that trade. His book (see above) was publicly burned at the Mercat Cross in Aberdeen. Meanwhile, Williamson took his case to the courts and won in 1765, bringing a successful suit against those engaged in the kidnapping trade.

Having made himself very unpopular in Aberdeen, he settled in Edinburgh where he became one of that city's well-known characters. He combined the several professions of pub owner, bookseller, printer and publisher. Williamson published the first street directory of Edinburgh in 1773 and also established a penny post in the city.

Williamson's many writings became very popular;

*"Travels of Peter Williamson amongst the different nations and tribes of savage Indians in America", "The Royal Abdication of Peter Williamson, King of the Mohawks."*

One famous portrait of Williamson shows him in the full dress of a Delaware Indian chief. "Indian Peter's" coffeehouse in Edinburgh was the "in" place because of the larger-than-life personality of "Indian Peter". Williamson was the most famous victim of a sordid and lucrative trade supported by many influential and supposedly respectable persons who never expected their victims to return to accuse them.

# V.  THE FUR TRADE

# ROBERT CAMPBELL

*Born. Dalchiorlich, Glen Lyon, Perthshire, 1808.*
*Died. Winnipeg, Manitoba, 1894.*

**He was often called simply, "Campbell of the Yukon."**

Campbell was persuaded to emigrate to Canada by his cousin, James McMillan, a chief trader with the Hudson's Bay Company, in 1830. He immediately began the legendary exploits which earned him his reputation as a trader and explorer. He risked starvation, Indian attacks and drowning. He made a 3000 mile trek on snowshoes, from Fort Simpson to the Mississippi River. His canoe journeys were epic as he became an expert trapper and hunter. He once saved his men by reading from the Book of Joshua to an angry band of Indians. Another time, he boiled up his snowshoes to make an edible paste which saved his men from starvation. He travelled through the northern wilderness for three days and nights without food, water or clothing, having been attacked and robbed by Indians.

His own son James Alexander was the first European to be born in the area of the Arctic Sea and later helped inoculate the Indians against smallpox. Although some of the men of the Hudson's Bay Company were motivated by greed and a desire for fame, Campbell refused to allow any of his discoveries to be named for him, making his name less well-known than others. Campbell's wife, Eleanora Stirling from Comrie, Perthshire was as remarkable as her husband, having made a difficult 6000 mile journey to be married to him.

Campbell is buried in the old Kildonan Church, at the site of the Red River settlement in what is now Winnipeg, having explored much of the wild Yukon. Robert Campbell was fond of taking a morning dip in ice-choked rivers, a source of wonderment to the astonished Indians. A North American writer of the time asked for "men to match these mountains." In Robert Campbell of Glen Lyon, he definitely got such a man.

# RAMSAY CROOKS

*Born. Greenock, Renfrewshire, 1787.*
*Died. New York, 1859.*

**Fur trapper and trader in the American and Canadian Rockies.**

Crooks emigrated to Montreal and immediately entered the fur trade with another Scot, Robert Dickson. He was in St. Louis at the height of the fur trade but found his ventures halted by Indian hostility. Crooks went back to Canada and began an overland journey to Oregon, under the employ of Astor's Pacific Fur Company. He became ill on the journey and was left behind, suffering from starvation and illness. Somehow, he managed to find his way to the Pacific with five other companions. He began the return journey with the Scot, Robert Stuart, and encountered Indian attack, blizzards, severe hunger and disease, but again, survived to reach St. Louis.

Crooks then used his knowledge and skills in the fur trade to advise John Jacob Astor on the future of the American Fur Company. Crooks ran the operation with great skill, making Astor a millionaire. Although Crooks was self-educated, his letters and notes became valuable records to historians of the western fur trade.

Crooks had always been frail, yet managed to survive time after time in impossible conditions. On his epic return journey with his fellow Scot Robert Stuart in 1813, he may have helped discover the famous South Pass through the Rocky Mountains which had a major impact on westward development. Crooks seems to have been that rare combination of hardness and intellect. It brought him fame and wealth. By the time he died in New York, he was a member and trustee of many of the leading learned societies in America.

# ISABELLA GUNN

*Born. Orkney, circa 1788.*
*Died. Orkney, 1861.*

**Isabella disguised herself as a man and served with the Hudson's Bay Company. Many songs and poems were written about her.**

The Hudson's Bay Company in Canada recruited many Scots to work in their outposts. The work was hard and dangerous - starvation, drowning and freezing to death were common, but the pay was good - if you were a man. For many centuries, the "Company" refused to employ women for all but the most menial of tasks. In 1806, Isabella disguised herself as a man and signed up for the Company as "John Fubister." She served as any other man, trapping, exploring, canoeing, etc. She once canoed for 1800 miles through the Manitoba wilderness and was well-regarded by her mates and officers. However, at least one man must have known her secret, for in the middle of Christmas festivities, this "John Fubister" gave birth to a baby boy!

Her secret discovered, despite her good work record, she was sent back to Orkney in disgrace, where she lived a life of poverty and vagrancy until she died and was buried in a pauper's grave in Kirkwall. She was often ill-treated and teased as "The Nor'wester."

However, her story did not end there. Her courage became the subject of many songs and ballads, some true to her story, some with embellishments. As early as 1810, she was the subject of a song in which she dressed as a man in order to follow her lover to the "men only" life as a Hudson's Bay fur trapper. The Canadian poet Stephen Scobie wrote an epic poem about her and she is the subject of Canadian folk singer Eileen McGann (late 1980's) in which Isabella continues her life of freedom with her son in Canada.

In truth, Isabella Gunn proved she was the equal of any man in the employ of the Hudson's Bay Company at the time, making her story both tragic and heroic. Her fellow fur trappers admitted later that "Isabella worked at any thing, and well, like the rest of the men." Isabella Gunn lives on, not as a pathetic old woman buried in a pauper's grave in Kirkwall, Orkney, but as the inspiration for song and poetry on both sides of the Atlantic.

# ALEXANDER MCARTHUR

*Born. Nairn, 1843.*
*Died. Winnipeg, Manitoba, 1887.*

Not every emigrant from Scotland achieved success; some were incurable dreamers. McArthur seemed to be one of these. He was educated at Nairn before arriving in Canada in 1861, where he worked as a clerk for the Hudson's Bay Company. He may have been arrested by Louis Riel in the Red River Rebellion; being freed, he set up as a successful businessman in Winnipeg.

McArthur was a competent local politician and was involved in many local scientific and learned societies. McArthur went through a rough spell of financial collapse while both his son and wife died within the same week. He had to sell his zoological specimens, books and beloved paintings.

Almost at once, he announced an expedition to the Arctic to collect birds. Some of the costs were financed by the Smithsonian Institute but the expedition was a disaster. In 1878, he had also tried unsuccessfully to import reindeer from Norway into the Canadian Northwest. Deep snow made the scheme impractical.

Alexander McArthur was obviously a man of great gifts who had more than his share of bad luck and bad timing.

# ALEXANDER MCKAY

*Born. Perth, 1841.*
*Died. Arizona, 1936.*

**One of the great Western characters.**

McKay emigrated from Scotland in the 1860's and sought his fortune as a gold prospector. However, McKay was one prospector who was usually lucky. He discovered gold in Arizona in 1878 and the town of Oracle was a result of his discovery. He introduced sheep farming into the area, devising a way to bring water down from the mountains. He discovered silver in 1883, opening up more of Arizona to settlement.

McKay was also involved in other schemes, however. In 1926, at the age of 85, he was arrested and jailed for producing bootleg whisky during Prohibition. His imprisonment was an action which incensed locals for whom Alex McKay was a pioneering legend. Alex made history by being pardoned by President Calvin Coolidge - the first ever prohibition pardon.

Alex lived to be 95 and was honoured as one of Arizona's great pioneers and citizens. His discoveries of gold and silver were key events in the history of that state.

# JAMES MACKAY

*Born. Kildonan, Sutherland, 1759.*
*Died. St. Louis, Missouri, 1822.*

**Explorer, map-maker, peace-maker.**

Mackay was an extraordinary man. He was fluent in Spanish, French and Gaelic and undertook the most perilous tasks assigned him by his employers in the fledgling fur trade. He is generally credited with being the first to describe and map the source of the Mississippi River. He worked in the fur trade for British companies in Canada and mapped and explored for Britain. He then settled in Spanish Louisiana and undertook the same tasks for the Spanish government. In 1795, he travelled with a party of 33 men into unexplored land on the Upper Missouri, with the purpose of making peace with the tribes he encountered. This was difficult but successful, thus paving the way for the famous Lewis and Clark expedition which came nearly a decade later.

Mackay played a major political role when the Spanish government transferred their lands to the expanding American nation.

James Mackay's deeds deserve wider recognition but if nothing else, he will always be remembered as the man who discovered the source of the mighty Mississippi River.

# ALEXANDER MCKENZIE

*Born. Stornoway, Isle of Lewis, circa 1767.*
*Died. Montreal, Quebec, 1830.*

**"The Emperor," "The Baron" of the Canadian fur trade. The least famous Alexander MacKenzie.**

This Alexander McKenzie was the nephew of the great explorer Alexander Mackenzie. He came from Lewis and arrived in New York, later going up to Montreal after the American Revolution. He traded around the Detroit area, then went west with the North West Company. From 1804-1808, McKenzie headed the Athabasca region of the fur trade and was known as "The Emperor" or "The Baron" for his high-handed manner.

McKenzie became embroiled in the violence between The Hudson's Bay Company and the North West Company when he was sent to destroy the Red River Settlement. He was accused of complicity in the murder of Governor Robert Semple and was acquitted in one of the most controversial trials in Canadian legal history.

His life quietened down after the merger between the two rival fur companies in 1821. He was a leading citizen in Montreal where he died in 1830. His lasting fame probably rests with his kinship with Sir Alexander Mackenzie, his uncle.

# DONALD MACKENZIE

*Born. Cromarty, Ross-shire, 1783.*
*Died. Maysville, New York, 1851.*

"He had a frame seasoned to toils and hardship, a spirit not to be intimidated, and was reputed to be a remarkable shot, all of which gave him renown on the frontier." Washington Irving, on Donald Mackenzie.

Mackenzie began his North American career with the Northwest Fur Company but soon threw his lot in with John Jacob Astor's American Fur Company. Mackenzie had acquired all the skills of a backwoodsman in the service of the Northwest Fur Company and was said to be feared and respected by the Indians. Mackenzie was more than just a good fur trapper. He seemed to have a sense of adventure without being careless or reckless. Mackenzie's life in the western mountains was the stuff of song and legend. It was told how Mackenzie once walked into an armed Indian camp to retrieve a stolen rifle. Mackenzie was fluent in most of the native languages and was thus invaluable as a scout and interpreter.

Donald Mackenzie was just one of many Highland Scots (and one of many Mackenzies) who lived the rough life of a fur trapper, explorer, Indian fighter (when necessary) and interpreter. Unlike many of the men in the west, he was immortalised by a leading American novelist of the time, Washington Irving. Mackenzie plays a leading role in Irving's "Astoria", an account of Astor's settlement on the Pacific coast. It makes exciting reading, even today - proof that truth is as entertaining as fiction.

Mackenzie was a massive man but so agile he was called "perpetual motion" by his men. Having risked starvation, grizzly attacks, torture, drowning and blizzards, Mackenzie survived to live the rest of his life in the quiet surroundings of upstate New York.

# KENNETH MACKENZIE

*Born. Ross and Cromarty, 1797.*
*Died. St. Louis, Missouri, 1861.*

**"King of the Missouri", "Emperor Mac-kenzie", "Emperor of the West".**

Mackenzie didn't inspire neutral feelings. People either hated him or loved him - but all respected him. Mackenzie cut his teeth with the Canadian Northwest Company as a merchant, trapper and explorer. He arrived in St. Louis in 1822, then the bustling gateway to the western fur trade. He promptly took out American citizenship and began his colourful career in the American fur trade. Mackenzie was a ruthless businessman but hired only energetic and fearless men like himself. He opened up trading posts and bought smaller companies in what was then a cut-throat industry. Once, when told that some of his trappers escaped an attack unharmed but their horses were lost, he replied that it would have been better the other way round.

He traded with the hostile Blackfeet and bravely took his trade to the heart of their country. Although one fort was named for him, it was from Fort Union on the Missouri that he gained his reputation as "Emperor." He played the role to the hilt, dressing in fine clothes, smoking imported cigars and sipping the best European brandy. His many Indian mistresses also dressed in European finery. Mackenzie had dictatorial control over all trading in the Upper Missouri and knew the movements of all those working in "his" area.

Rival trappers claimed Mackenzie sold guns to the Indians in order to kill off his fur trade rivals; a charge Mackenzie never denied. He was also accused of running an illegal still at Fort Union, manufacturing corn liquor. This was a very serious charge and Mackenzie thought it would

be prudent for him to disappear from the area for a while. He went to Europe and began to import wines into America. On his return, he continued his imports and began to speculate in land and railways, making a vast fortune in both.

He was a legendary character in St. Louis, then full of legendary characters. The "Emperor" was very much a man of the west and westward expansion and his contribution to exploration was enormous. He embodied many of the best and worst qualities of the fur trade. He was a kinsman of the great explorer Sir Alexander Mackenzie and deserves the same recognition.

# RODERICK MACKENZIE

*Born. Assynt, Sutherland, 1771.*
*Died. Red River Settlement, Manitoba, 1859.*

**"Captain of the Nipigon"**

There were several Roderick Mackenzies in the North American fur trade so facts are sometimes confused about their individual lives. Mackenzie's fur trapping life was centred around Ile-a-la-Crosse, Saskatchewan, with the North West Fur Company. His principal trading partners were the Chipewayan Indians who were also under pressure from missionaries and rival fur companies. Mackenzie was a compulsive worker, consistently returning high profits for his company. The explorer Thomas Simpson described him as a "well-meaning, warmhearted but passionate and crabbit old Highlander" but he carried on, limping and nearly blind. He retired with his Ojibway Indian wife and large family to the Red River settlement which was too civilised for his liking.

Mackenzie invested wisely, building up a comfortable fortune. He never returned to Scotland and remained a fine example of a company man; all seven of his sons went on to work with the Hudson' Bay Company and four of his five daughters married men who worked for the Company.

Mackenzie lived to be an old man, a privilege not afforded many in the dangerous fur trade.

# DONALD MACLEAN

*Born. Tobermory, Mull, 1805.*
*Died. Chilcotin, British Columbia, 1864.*

**He ruled
the "Siberia
of the fur
trade" with
"club law".**

MacLean joined the Hudson's Bay Company in 1833 as an apprentice clerk and made his way quickly up the ranks in this quasi-military company. MacLean took part in several key explorations in the west and was eventually in charge of the post at Fraser River where the Company sent its worst discipline cases for punishment, hence the "Siberia of the fur trade". MacLean had to rule with a rod of iron. When one of his employees was killed by an Indian, MacLean reacted by killing two men and an infant in the tribe, saying the murderer, Tlelh, should be hung first and tried later. MacLean was building up his own cattle herd and also became an expert horse breeder. Eventually, MacLean's harsh methods failed to impress his employers and he retired to his own ranch, running an inn for travellers: "MacLean's Restaurant" in the Cariboo Country. Despite his vengeance against some Indian tribes, MacLean's own wife was a Colville Indian.

MacLean probably was responsible for worsening relations between white and Indian. In 1864, the Chilcotin Indians killed 19 road workers in British Columbia and MacLean was elected to bring the killers to justice; however, MacLean, scouting alone, was ambushed and killed. The Indians refused to disclose his killer, regarding the act as just retribution for some of MacLean's excesses in the past.

Tragically, MacLean's three youngest half-caste sons, Allan, Charles and Archie were hung in 1879 for murdering a constable. There was further irony: the son of one of those men was decorated in 1917 for killing 19 Germans single-

handed.

MacLean was a walking contradiction. He was hated by many tribes and by many of his fellow fur trappers, but he was devoted to his own Indian wife and children. It seems he had a fierce sense of justice which didn't allow exceptions; in the end that same code of justice was used against him.

# JOHN MACLEOD

*Born. Lochs, Isle of Lewis, 1795.*
*Died. England, circa 1860's.*

**Capable explorer in Canada's Northwest Territory.**

MacLeod left Lewis for Montreal in 1816. His career was at first undistinguished, however MacLeod's mental tenacity was noted and he was given more and more responsibility. The great explorer Sir George Simpson termed him "a young Gentleman of much promise...and I am much mistaken if he does not turn out to be a valuable acquisition."

MacLeod seems to have been given the less glamorous tasks. He explored several mountain ranges and befriended the Nahanis Indians in the area. He helped check the flow of Russian fur into the area. He found the source of the Liard River's west branch and met five new Indian tribes on this successful voyage. Sir George Simpson noted the young man's value to the fur trade:

"Macleod is an active well behaved Man of tolerable Education. Speaks Cree, understands a little Chipewayan is an excellent Trader and has late been employed on Severe exploring Service."

In 1834, he undertook one further valuable expedition for the Company, exploring unknown country around Dease Lake. He studied trading possibilities with the coastal tribes. He was sent on many more missions, including trips to sell supplies to American fur trappers in Wyoming. He found a party of lost trappers in California, enlisting help from the Mexicans and Russians.

He seemed to complete every task assigned to him. MacLeod retired from Company service in 1842 and returned to Britain for good. Mount MacLeod, west of Dease Lake, was named for him.

# LETITIA MACTAVISH

*Born. Edinburgh, Midlothian, 1813.*
*Died. Sault St. Marie, Upper Canada, 1854.*

**The wife of a chief officer in the Hudson's Bay Company, she left us valuable accounts of frontier life and the life of native peoples who called her "Hockimaw Erqua" - Chieftain-ess.**

Letitia MacTavish grew up near Campbeltown, Argyll, receiving a good education. Many of her family had been involved in the Canadian fur trade and it was natural for her to marry into it. Her husband was a Chief Trader with the Company and she was posted with him to the bleak trading post at York Factory, where she was the only white woman. Her letters back home gave an intimate portrait of that harsh life from a feminine point of view.

Her life was relatively comfortable but she was able to build up a good rapport with the Indian women in the area. She showed great sympathy for native women and their customs and her opinions sometimes clashed with those of local ministers and educators. Her letters and writings continued to detail the life of the wife of a Chief Trader with the Hudson's Bay Company; as such, they are some of the first writings by a woman in Canada. She returned to Scotland for medical treatment in 1846 and died of cholera in Sault St. Marie in 1854.

Her accounts of life at York Factory in the early 19th century are unique in Canadian letters.

# JOHN MELISH

*Born. Methven, Perthshire, 1771.*
*Died. Philadelphia, Pennsylvania, 1822.*

**Geographer, traveller, merchant. One of America's great map makers.**

Melish was apprenticed to a wealthy cotton merchant and began his cotton career in Savannah, Georgia. Although Melish was a successful merchant, he also hoped to travel widely and publish accounts of his travels in America. He returned to Scotland in order to bring his family back with him to New York. His first published works were a big success - and praised for the accuracy of the maps included. His writings were also well-received for their fair mindedness; most travellers up to that time had been highly critical of American customs and culture. Melish's works were even and factual; his maps were amazingly accurate for the time; many stood the test of time. He next published a map of the War of 1812 which again met with approval both with scholars and the general public. The Philadelphia Directory of 1813 lists him simply as a "merchant". By 1818, he is "a geographer, engraver and map publisher".

Many more important works followed: maps on Pennsylvania, West Florida and the Bahamas, the first "road" map of the United States, maps of British and Spanish territory in North America, etc. He also wrote widely on the political economy of the United States and published the valuable "Information and Advice to Emigrants to the United States" in 1819.

John Melish had acquired a reputation for truth and accuracy in all his writings. He died in Philadelphia and was buried in the Free Quaker burial ground in that city. His name is hardly known today, though his maps have become priceless collectors' items.

# WILLIAM PANTON

*Born. Aberdeenshire, 1742.*
*Died. At sea, near Nassau, 1801.*

**As an Indian trader, Panton had a great effect on the history of the Old Southwest along the West Florida Frontier.**

Panton first went to South Carolina and later entered a firm of traders who operated in East Florida, trading with the Creek Indians. His Loyalist position during the American Revolution resulted in confiscation of property and the label of "outlawry" pronounced by the Georgia Provincial Congress. Panton moved to West Florida, then under Spanish control. However, the Spanish government saw Panton's trading activities as vital to good relations with the southern Indians: the Choctaw, Creek, Chickasaw and Cherokee. His trading activities extended to Havana and New Orleans. Panton kept his firm alive despite the complications of dealing with the Indians, the Spanish, the British and the Americans. He died at sea and was buried at Great Harbours, Berry Islands, on the way to Nassau.

He was a great figure in a colourful and confusing time in American frontier history.

# JOHN RAE

*Born. Stromness, Orkney, 1813.*
*Died. London, England, 1893.*

**He is said to have walked over 23,000 miles in the Canadian arctic. He helped solve the mystery of Lord Franklin's disappearance.**

It is over forty miles from Toronto to Hamilton, yet John Rae once covered that distance in snowshoes in order to keep a dinner date! Still, what's forty miles to a man who covered the length and breadth of the Canadian wilderness? John Rae, a native of Orkney, worked for the Hudson's Bay Company as did many other men from his native island. Rae was employed as a surgeon in the Company, but spent much of his time in scientific study and exploration. He invented the "sun flyer", a balloon which used solar heat for flight.

Rae had learned to travel from the Indians: travel quickly with little gear, live off the land as you go. He was asked to explore dangerous and uncharted territory, but was always able to do so. When Lord John Franklin disappeared on his final voyage, Rae was the natural choice to solve the mystery. Although he never found much hard evidence, Rae did narrow the search, thus preventing further fruitless wanderings. Moreover, Rae had charted over 5380 miles of wilderness, including over 700 miles of previously unknown coastline.

Later, Rae surveyed the land which made telegraph possible from Winnipeg across the Rockies. He traversed the most dangerous parts of the Fraser River without a guide. Rae was also involved in scientific and political matters for the rest of his life, and was much respected throughout the world. He is buried in the churchyard of St. Magnus Cathedral in Kirkwall, Orkney.

We must still marvel at the courage and hardiness of this Orkneyman who travelled the Arctic like an Eskimo, recording everything he saw for posterity.

# ALEXANDER ROSS

*Born. Nairnshire, 1783.*
*Died. Winnipeg, Manitoba, 1856.*

**Trapper, trader, explorer, writer.**

Ross was unusual for a fur trapper - he emigrated not to trap but to teach school - in what is now Ontario. After three years teaching, the spirit of adventure overtook him and he enlisted in John Jacob Astor's Pacific Fur Company. Ross spent much of 1811 making a hazardous canoe journey up the Columbia River, into territory where few had ventured. He ran a fort alone but soon proved an excellent diplomat with the native peoples, completing a successful mission by returning to Astoria on the Pacific Ocean. He had travelled over 3400 miles.

Despite the war between Britain and America and several changes of employment, Ross was still in great demand as a trader and explorer, with rival companies often bidding for his services. He would found a trading post, establish good relations with the natives, train someone to run the post, then set off on further explorations.

He was one of the first to explore the wilderness around the scenic Snake River. He was awarded a land grant in the Red River Settlement in Manitoba, where he settled with his family. Ross was also unusual in his interest in the languages and customs of native people. He studied their ceremonies, religion and art, keeping diaries and notebooks of his encounters with the Indians. He published admirable accounts of the tribes of the Columbia River basin and the Pacific Northwest.

Alexander Ross is yet another remarkable example of a Scot who used his own wit and intelligence to survive in a harsh land, while recording the customs of its native peoples. His accounts are still read with great interest today.

# ALEXANDER SIMPSON

*Born. Dingwall, Ross-shire, 1811.*
*Died. Scotland, circa 1845.*

**He sought the truth of his older brother's death.**

Simpson was the younger brother of the famous explorer Thomas Simpson and cousin to George Simpson, governor of the Hudson's Bay Company so it was natural for him to enter the fur trade; he did so at the age of 16. However, young Alexander did not take kindly to his rather boring duties as a clerk and thirsted for exploration and adventure, especially as he had been punished for "looking rather too tenderly on one of the Maid Servants" of superintendent James Keith.

The Company expanded its operations to California and what is now Hawaii. Alexander Simpson was a key figure in establishing these enterprises, being made chief trader in 1841.

Simpson learned of his brother's mysterious death and made some investigations into it as well as returning to Scotland to comfort his parents. Simpson was convinced his brother was murdered, later hinting that George Simpson had some complicity in the affair. Alexander got involved in some unwanted political intrigue in Hawaii over the possible annexation of the islands by the British, a case Alexander espoused - much to the discomfort of the Hudson's Bay Company. Alexander Simpson later resigned from the Company, leaving accounts and records of his time there. He edited his brother Thomas' posthumous accounts of his travels and explorations and that is probably the service Alexander Simpson is best remembered for in his relatively short life.

Alexander remained convinced that his brother was murdered and that suicide was offered only as an excuse for a major cover-up.

# GEORGE SIMPSON

Born. Lochbroom, Ross-shire, 1792.
Died. Montreal, Quebec, 1860.

**Hudson's Bay merchant and explorer. Called "the fastest traveller in the Far North".**

Simpson was one of three famous kinsmen (Alexander and Thomas being the other two) who explored the Canadian wilderness on behalf of the Hudson Bay Company. He entered the Company's service in 1820 and was soon entrusted with control of Company affairs. Simpson had to rule with an iron hand and had to deal with all company matters involving competition from other fur trading interests. Simpson was a skilled politician and diplomat, as well as a shrewd judge of character. Some also said he was ruthless and cunning. He was equally at home shooting the rapids in a canoe or in a bank office in Montreal. Simpson was able to cover great distances quickly and once travelled by canoe from Hudson Bay to the Pacific, a distance of over 3200 miles. He also explored Siberia and other parts of the Arctic. He aided John Rae's expeditions. In later life Simpson became Director of The Bank of British North America.

Simpson was a visionary who had original ideas on agricultural reform. Moreover, he survives to this day on the Canadian map: Simpson's Falls and Cape George Simpson, among other places. It was a rags to riches story, too. He was born out of wedlock in a remote Highland parish, rising to become head of the wealthiest bank in Canada, having risked starvation and drowning countless times en route.

# THOMAS SIMPSON

*Born. Dingwall, Ross-shire, 1808.*
*Died. Dakota Territory, 1840.*

**This young man may have discovered the fabled Northwest Passage on foot nearly seventy years before Roald Amundsen was credited with the discovery.**

Sir George Simpson of the Hudson Bay Company was Thomas Simpson's uncle, so it was only natural that young Simpson grew up with tales of adventure in the North American wilderness. Thomas had studied for the ministry but was dying of consumption. His family urged him to take up an adventurous life in the fresh air, hoping it would cure him. From 1837 to 1839 he explored much of the Arctic territory. In the summer of 1839, Simpson walked eastward to the Boothia peninsula where he narrowly missed discovering the connection to the icebound sea which would have verified the Northwest Passage. Simpson thus nearly discovered what had eluded mariners for over 500 years.

Simpson proved himself a hardy and reliable explorer; what's more, his health was restored. He remained at the Red River settlement throughout the summer of 1840, then set off for a journey to the East, in order to begin a return journey to Scotland; but Thomas Simpson never reached home. On the 14th of June, 1840, he was shot to death by one of his travelling companions who claimed Simpson had gone berserk and began to shoot his own men. Another version claims that Simpson became deranged and shot himself. Thomas' brother Alexander, who also worked for the Company, was convinced that Simpson was murdered by two renegades who bore him a personal grudge, or who thought he had valuable maps in his possession which he refused to give to them. Alexander Simpson also published "The Life and Travels of Thomas Simpson" (1845) which gives us a good account of his brother's

explorations and achievements.

The natives of Dingwall have no doubts about Simpson's value as an explorer. Although he was unable to be buried in consecrated ground in his native place as a suspected suicide (his remains are buried in Winnipeg, Canada), a public inscription in the local museum reads:

"In memory of Thomas Simpson, a native of this county and burgh, who departed this life on the 15th of June, 1840, a few days before he had completed his 32nd year. Though removed so early he had already attained the high distinction of being the discoverer of the long-sought Northwest Passage."

It is now almost certain that Thomas Simpson did not commit suicide, therefore there is now no reason why he could not be buried with much pomp and ceremony in his native kirk yard; explorer come home to rest.

# SIR WILLIAM DRUMMOND STEWART

*Born. Murthly Castle, Perthshire, 1795.*
*Died. Perthshire, 1871.*

**"The Buckskin Baronet."**

William Drummond Stewart was born into an aristocratic Perthshire family. He became an officer in the British cavalry, distinguishing himself at the Battle of Waterloo. Against the wishes of his family and colleagues, Stewart went to America in search of fortune and adventure. He certainly found the latter. For a total of eight years, Stewart lived the life of a frontiersman and fur trapper, albeit a well-heeled one, taking luxurious foodstuffs and accessories with him to the wild Rocky Mountains. Stewart became a favourite with both white trappers and natives and was renowned for his sound mountain sense and rifle skills. Stewart was accepted by the men of the far west. On one trip, he took Alfred Jacob Miller with him; Miller was an American artist who captured much of the frontier life on canvas - the only pictorial records we have of that turbulent and exciting time.

Stewart, the 7th Baronet of Murthly, returned to his castle in Perthshire with buffaloes, Indians, fur trappers and his faithful guide, Antoine Clement. High society visitors were regaled with tales of Stewart's adventures in the Wild West and shown various paintings and artifacts of his time there. Anecdotes about some of Stewart's guests abound: there is a story that some bored Indians and frontier guides hooked up a row boat to some wheels and were pulled through the streets of Dunkeld by wild buffalo yoked to the contraption.

Stewart was an eccentric but was also shrewd

enough to have made a considerable fortune in America with railroad shares. On the surface, he enjoyed the good life of an aristocrat but all who knew him recognised his longing for his Wild West: life among the Crow, Blackfeet and Shoshone. It is also certain that the great characters of the frontier included Stewart among their ranks, even as he dispensed his fine claret and showed the Indians a suit of mediaeval armour; even while his buffalo grazed on the sweet grass of Perthshire.

Captain William Drummond Stewart played an important part in the exploration of the American West, encouraging those with him to respect and record all they saw.

# ROBERT STUART

*Born. Callander, Perthshire, 1785.*
*Died. Chicago, Illinois, 1848.*

**"He rivalled Sinbad."**

Robert Stuart was the grandson of Alexander Stuart, Rob Roy MacGregor's worst enemy. He migrated to Canada in 1806, working as a fisherman in Labrador. He made countless dangerous expeditions with the French voyageurs and was the third man ever to cross the American continent by canoe. He became a leading partner in John Jacob Astor's fur company, helping establish many settlements in what is now Oregon.

One of his epic journeys (in the company of Greenock man Ramsay Crooks) took him from the Pacific Coast to St. Louis, surviving incredible privation and hardship and earning him the undying respect of tough frontiersmen. Stuart then took over as head of the American Fur Company in the Upper Great Lakes Region. After his life of adventure as a fur trader and free trapper, he settled down to civic affairs in Detroit, particularly in the area of poor relief. He was admired for his work done as Superintendent of Indian Affairs for Michigan. Stuart owed much of his success as a trader to his understanding of Indian languages and customs. He was admired by the Great Lakes tribes for his understanding of their ways. Stuart died on a business trip to Chicago and was buried in Detroit.

Stuart himself was a contradictory character. He had great admiration for the Indian way of life but remained a staunch Presbyterian. He had great sympathy for his fellow man but once fractured the skull of an employee. He helped runaway slaves escape and advocated better treatment of the American Indian. He was

described by his fellow trappers as a "severe" man but his letters to fellow trader Ramsay Crooks reveal a much kinder and humorous side.

Robert Stuart was once described by the great American writer Washington Irving as "an easy soul of social disposition". Perhaps the greatest testimonial to Robert Stuart is that the Indians said he was the only white man who had never lied to them, who had never broken a treaty or a promise.

He was exactly what you'd expect from a man whose own grandfather stood up to Rob Roy MacGregor.

# VI.  WORDSMITHS

# HELEN
# ADAM

*Born. Glasgow, Lanarkshire, 1910.*
*Died. Brooklyn, New York, 1993.*

**Minister's
daughter,
ballad
maker,
friend of
the San
Francisco
Beat poets.**

Daughter of a Presbyterian minister, Helen Adam was already a widely-published poet in her early teens. She attended Edinburgh University, becoming a journalist until ill-health forced her to emigrate in the late 1930's. San Francisco became a haven for the Beat Poets of the 1950's and Helen Adam soon appeared at public readings with Robert Duncan and Allen Ginsberg.

Her poems, ballads and stories were published in many quality small presses in America and she was also the subject of documentary films. She was a well-known character, once featuring in her own ballad opera "San Francisco's Burning".

Her last few years were spent as a recluse, after the death of her much-loved sister.

Her book, "Selected Poems and Ballads", was published by Helikon Press while her stories were collected by Hanging Loose Press in Brooklyn, New York.

# ROBERT AITKEN

*Born. Dalkeith, Midlothian, 1734.*
*Died. Philadelphia, Pennsylvania, 1802.*

**America's greatest printer and publisher.**

The American Revolution had one grave consequence for almost all Americans. War with Britain meant that America could no longer receive shipments of Bibles from London - the only source for Bibles at that time. A Scottish printer in Philadelphia stepped in to rescue the struggling Colonies from this deficiency. In 1777, Aitken issued a New Testament, and in 1781, he printed the entire Bible. To this day, "The Aitken Bible" remains the first complete English-language Bible printed in America and the only one ever authorised and approved by the United States Congress. The "Aitken Bible" was probably the biggest factor in the education of America at the time.

However, Aitken's contributions extended to many fields, and he printed maps, street plans and engravings. Aitken was also one of the few editors to persuade the radical Tom Paine to sit down and write to deadline. Aitken was said to keep brandy solely for the purpose of loosening Paine's tongue and pen.

Aitken was considered the best printer of his day in America and was described as "a man of truth and irreproachable character".

Aitken was a major historical figure in America. His publishing career had a profound influence on that nation.

# ROBERT BELL

*Born. Glasgow, Lanarkshire, 1732.*
*Died. Richmond, Virginia, 1784.*

**Said Bell: "No one should be restricted and fettered in a free state in the propagation of literature."**

Bell came to America after unsuccessful business ventures in Scotland and Ireland. He set up as a bookseller and auctioneer; soon his auctions became literary "happenings" in Philadelphia. Bell sat, jugs of beer at hand, and drank scurrilous and comical health to his customers while passing comment on author and book alike. Bell took his show on the road and became an eccentric celebrity. His book business prospered. He also operated one of the first lending libraries in America, while arguing against any restrictions on bookselling and publishing in the new American nation.

Bell served the Revolutionary cause in the greatest possible way by being the first to publish Thomas Paine's "Common Sense" in 1776. He also published the first American edition of Blackstone's legal "Commentaries" which became the basis for the American legal system. Bell's auctions continued to be the best entertainment around and many famous people attended in order to see this droll Scotsman sell his wares in Philadelphia.

Robert Bell was an original character who blended the comic with the serious while establishing fundamental freedoms in America. His most valuable legacy was publishing the revolutionary work of his friend Tom Paine - the man nobody else would dare publish at the time.

# JAMES GORDON BENNETT

*Born. Newmill, Keith, Banffshire, 1795.*
*Died. New York City, 1872.*

**Colourful New York City journalist and editor. Fierce defender of the freedom of the press.**

Bennett had planned to study for the priesthood in Aberdeen but decided instead to emigrate to New York to seek his fortune. He arrived with no money, risking starvation, before he landed a job with the New York Enquirer, whose editor had just been killed in a duel. Bennett had what it took to survive in the cut-throat world of New York news gathering; in 1835, he founded the famous New York Herald. His desk was a plank balanced on two empty flour barrels but it was from this cellar that he became the leading popular journalist of the day. He was punched, spat on in the street, cursed and vilified - but he always got a story. He kept his own fleet of dispatch boats and telegraph crews in order to beat rivals to the daily news.

One half of New York lionised him - the masses who read his papers. Others accused him of filling the Herald with "vulgarity, vituperation and scandal" - but even his critics read the paper avidly.

Bennett was constantly in legal hot water and many attempts were made to discredit him and his beloved paper; rivals called Bennett that "Obscene foreign vagabond". He was accused of sedition, libel and slander on many occasions. However, Bennett did not shrink from exposing scandal and corruption - albeit in lurid terms, but he is now considered one of the great defenders of freedom of the press in American history.

# JAMES THOMSON CALLENDER

*Born. Scotland, 1758.*
*Died. By drowning, Richmond, Virginia, 1803.*

**Fled to America, having been branded "a fugitive and an outlaw".**

James Callender had all the advantages of a Scottish classical and legal education but like many young men of the day, he looked to France and America for his political ideals: republicanism and the equality of man. However, these ideas could get a man hung or transported in 1790 and many leading radicals were being rounded up by the authorities in Scotland. He had to flee in 1793 for supposedly seditious writings which branded him a political "fugitive and outlaw". He arrived in Philadelphia, siding with Thomas Jefferson in his political struggles with the Federalist Alexander Hamilton. Callender wrote some scurrilous things about Hamilton's private life and once more had to face sedition charges. He next attacked President John Adams and was tried for sedition, fined and imprisoned.

Ever the fiery Scot, Callender continued his attacks on American politicians. His writings were smuggled out of prison in order to reach an admiring audience. Thomas Jefferson became President and pardoned Callender, but the fearless Callender next turned his guns on Jefferson himself, accusing Jefferson of dishonesty, cowardice and personal immorality. However, Callender's attacks seemed to affect his mind, and his own behaviour became more and more bizarre. His four children were taken into care (his wife had died some years earlier) and he retreated into alcoholism. He often threatened suicide but was prevented from taking his own life on several occasions. Walking back from a pub late one night, he slipped and fell into the James River, drowning in less than three feet of water.

Callender never shrank from the truth; however, his own love of liberty deprived him of life itself.

# SIR WILLIAM CRAIGIE

*Born. Dundee, Angus, 1871.*
*Died. Scotland, 1957.*

**World authority on language; wrote the definitive study of American English.**

Craigie was born in Dundee and educated at St. Andrews, Oxford and Copenhagen, becoming an authority on Scandinavian folklore and language, especially Icelandic. He was one of the major compilers of the Oxford English Dictionary, while serving as Professor in Scandinavian and Anglo-Saxon at Oxford.

Craigie's most significant work was done while Professor at the University of Chicago from 1925-1936, where he compiled the monumental *Dictionary of American English* in four volumes, which was completed in 1944. This was not only a scholarly work; it acknowledged the richness and historical diversity of an English in no way inferior or derivative. Many of the terms listed were peculiarly American; others were American versions of older English terms. Craigie's work had a colossal impact on American language, proving invaluable to scholars, students and historians.

Craigie also worked on the famous *Dictionary of the Older Scottish Tongue* while at Chicago. Subsequently he was knighted and later honoured by the Icelandic government for his work. He was President of the Scottish Texts Society doing much work on behalf of Gaelic and Scots.

It took a Scotsman like Craigie to prove to the Americans the richness and historical vibrancy of their own language, producing one of the most important books in American culture.

# THOMAS DAVIDSON

*Born. Old Deer, Aberdeenshire, 1840.*
*Died. New York State, 1900.*

**Gypsy scholar, wandering philosopher, friend of the poor.**

Davidson, born into good North East farming stock, was a leading scholar, linguist and radical philosopher in Europe and North America. He spoke most of the modern European languages and was fluent in Latin and Greek. He was said to have a photographic memory.

Davidson was a free and radical thinker, and enjoyed the life of a wandering teacher, ending up in Boston, and later, St. Louis, Missouri. He lived the life of a religious hermit in Italy but later settled in the mountains of upstate New York. He became famous for his work with the "Bread Winners College" in the slums of the Lower East Side of New York City. His purpose was to bring education to those who didn't have educational opportunities. The successful project had a major impact on adult education in America, proving that education wasn't a monopoly of the middle classes. Davidson made an impact on every person he met and was described as a remarkable teacher and humanitarian. He remained modest and friendly, managing to practice what he preached, making his ideals work. He influenced many of America's leading educators and thinkers.

It may seem a long way from the parish of Old Deer to the slums of New York City, but Davidson travelled that road bravely, like so many Scots before and after him.

# WILLIAMINA PATON FLEMING

*Born. Dundee, Angus, 1857.*
*Died. Massachusetts, 1911.*

**She measured the heavens and counted the stars.**

To most of us, one star looks much the same as another. Williamina Fleming saw stars differently. Although she was trained as a school teacher, she emigrated with her husband in the furtherance of his own career. Having no training in astronomy, she was hired by the Harvard College Observatory to do fairly routine clerical tasks. She was put in charge of the photo library, which had come about as the result of a new technique of classifying stars by means of prism plates. Until this discovery, stars were classified into only four major types, based on spectra. Mrs. Fleming soon expanded that classification, helping to identify over 10,000 stars. Moreover, she was one of the first to classify stars having "peculiar" spectra - that is, not fitting into the usual categories. She discovered ten new novae and did pioneer work on variable stars. This was all done without the benefit of any formal training in astronomy!

She was made an honorary member of the Royal Astronomical Society of London. Her methods and discoveries are still important and she pioneered new methods of classifying stars for scientific reference. Other Scots had explored the inhospitable wastelands of our planet; this Dundee school teacher took her explorations even further and thus made a lasting contribution to astronomy.

# JOHN GALT

*Born. Irvine, Ayrshire, 1799.*
*Died. Greenock, Renfrewshire, 1839.*

**This Scot had a colourful career on both sides of the Atlantic.**

Although Galt is best remembered as a writer and novelist, he was also involved in the political and cultural life of his day. He began his working life in the Greenock custom house, but moved to London to study law. He later established a trading company to try to break Napoleon's embargo against British goods entering Europe. Despite his many business interests, Galt had already written six novels in two years, while trying to write school textbooks at the same time, (under the unlikely pen name of "Reverend Clark").

Galt was appointed Secretary to the Canada Company, a group formed to settle and develop the Canadian wilderness. Galt threw himself into his Canadian duties with his usual energy; as a result, the area of Upper Canada (now Ontario) grew prosperous. However, Galt was not one to rest on his laurels or to sink into apathy. He felt the Canadian settlers (many of them Scots) were being either ignored or exploited by British interests and he spoke out against this situation. He was hastily recalled to Britain by the Canada Company and charged with negligence in his Canadian duties, which earned him several months in the King's Bench Debtors' Prison in 1829.

His novel "Lawrie Todd" was based on his Canadian experience. It was also inspired by the life of another colourful Scot in North America, Grant Thorburn, a political radical and horticulturalist who founded a prosperous seed company in New York. Galt's contribution to Canadian life was lasting. He founded the town of Guelph, Ontario and had another town, Galt,

named after him. He also had a hand in writing that most haunting poem, "The Canadian Boat Song", which he suggested to a Scottish friend, David Moir. Also, Galt's son became a leading politician in the Canadian government.

Galt, the son of a West Indian sea captain, was ever controversial but his achievements will be long remembered in both Scotland and Canada.

# WILLIAM GOWANS

*Born. Lanarkshire, 1803.*
*Died. New York City, 1870.*

Gowans was not your average genteel bookseller. He had been a flatboatman on the Ohio River at about the same time as the young Abraham Lincoln and we know from Lincoln's own writings that this job was not for the faint-hearted. Gowans also tried stone-cutting, news vending, gardening and acting (he had once been a lodger in a house owned by Edgar Allan Poe). Gowans entered the book trade where his bookshop on Nassau Street in New York City became a type of curiosity shop. Books were piled to the ceiling, spilling over into the basement and out the windows. "Books lay everywhere in seemingly dire confusion" said one famous visitor to the shop. Gowans didn't mind. In fact, he seemed pleased not to have to sell the books which he considered part of his shop furniture.

But Gowans did do important work, issuing catalogues and reprinting many historical works. His death brought unexpected problems. He left over 250,000 volumes and several tonnes of pamphlets which had to be sold for scrap paper.

Gowans was a well-known eccentric in a New York then famous for eccentrics. Yet, he had the respect of other booksellers and was said to bring a certain vigour and freshness to the book trade in the city. He was also said to be the first to judge books by their historical worth rather than by elegant bindings and fancy paper. He was nicknamed "The Antiquarian of Nassau Street".

# JOHN MACDONALD
## (MACDHOMHNAILL, 'IC, IAIN, IAIN)

*Born. Lochaber, Inverness-shire, 1795.*
*Died. South West Mabou, Nova Scotia, 1853.*

**Iain Sealgair, "John the Hunter". Gaelic poet, author of the popular "Oran do dh' America" - "Song to America" - about the hardships of American emigration.**

John MacDonald was a gillie on an estate owned by an Englishman in Lochaber. He was an excellent shot and could snuff out a candle with a rifle shot. In fact, he was such a good shot he became simply Iain Sealgair - "John the Hunter". He never shot at stationary targets but always frightened deer so as to fell a moving target. He was writing poetry as a young man and wrote his famous "Oran a' Chnatain" - "song to a cold" when he was only 20.

He emigrated with his brother Angus, his own wife and his sister Chrissie in 1843 on the ship Seonaid which landed at Port Hawkesbury, Cape Breton. He settled in South West Mabou district. John MacDonald did not take to his new home. The first "winter of the big snow" made him want to return to Lochaber. Shortly after his arrival, he wrote the bitter "Song to America" contrasting his old life in Scotland with his new life in Nova Scotia. "Alas, Lord, that I turned my back on my country of my own free will.....". MacDonald 's opinions did not endear him to his neighbours, especially since MacDonald's life in Canada seemed a comparatively easy one (he had brought lots of money with him). His cousin Allan MacDonald who lived nearby hastened another poem in reply, reminding Iain Sealgair that life in Scotland had its problems too.

MacDonald didn't seem to soften his attitude but his songs and poems have a special place in Nova Scotia as the voice of the nay-sayer, the sceptic, the refusenik. He lived well enough in Canada and certainly never volunteered to go back to Lochaber.

# WILLIAM ADDISON PHILLIPS

*Born. Paisley, Renfrewshire, 1824.*
*Died. Kansas, 1893.*

**A radical anti-slavery journalist who also fought for the rights of native Americans.**

The Phillips family emigrated when William was a boy. They settled in Illinois. William became a newspaper editor in Chester, Illinois and later studied law. He became well-known as a radical anti-slavery journalist and did much to prevent Kansas from becoming a pro-slavery state. He helped found the town of Salinas, Kansas. When the American Civil War broke out, Phillips commanded an Indian regiment, winning many important skirmishes for the Union side in the Indian Territories.

After the war, he continued to argue for a fairer political system based on democratic socialist principles of taxation and land distribution. He was elected to Congress in Washington, D.C. and helped generate support for land legislation, savings banks, income tax reform and the rights of Indians. His experiences in Kansas as an officer in charge of Indian regiments gave Phillips great sympathy for the plight of the western tribes. He fought in the courts for the land claims of the Cherokee tribe.

William Addison Phillips continued his fight for political reform until his death. He also wrote fiction and poetry. In later years when American journalism exposed corruption in big business, Phillips was cited as an inspiration for journalists. His is a name that is central to American history but it shouldn't be forgotten that Phillips was firmly in that great Paisley tradition of radicalism which had a great impact on both sides of the Atlantic.

# JAMES REDPATH

*Born. Berwick-on-Tweed, 1833.*
*Died. New York City, 1891.*

**Journalist, editor, lecture promoter, social reformer.**

James Redpath went with his family to Michigan and entered the printing business; from there, he joined the staff of the great reforming newspaper, Horace Greeley's New York Tribune (one of whose foreign correspondents was Karl Marx). Redpath became a crusading anti-slavery journalist in the years leading up to the American Civil War. He toured the Deep South, talking to slaves and slave owners alike, writing a major book on the subject. He also wrote extensively on the life of the martyr John Brown.

Redpath became convinced that Haiti would provide a safe haven for freed southern slaves and began to organise black emigration to Haiti. He became a champion of Haitian independence, helping to get that nation officially recognised. He was a war correspondent with the Union Army during the Civil War. After the war, he revamped the education system in Charleston, South Carolina; his many reforms there included the founding of an orphanage for negro children.

This era also saw the rise of the popular public lecture and he founded a lecturing bureau - The Boston Lyceum Bureau (later, The Redpath Lyceum Bureau) - whose speakers included Emerson, Beecher, Thoreau, Mark Twain and Josh Billings. His bureau became America's foremost lecturing circuit.

Redpath never gave up crusading for justice. His tours of Ireland stirred him to write against English rule and landlordism. He later became editor of the influential North American Review. He was run over by a street car in New York City and died five days later. He was one of America's most able crusaders yet his name is now little-known there.

# JOHN REGAN

*Born. Ayrshire, 1819.*
*Died. Illinois, circa 1880.*

**Wrote the influential "Emigrant's Guide" for Scottish settlers in America.**

John Regan emigrated to Illinois as a young man and there built a log cabin, raised crops and taught school. Regan was struck by the similarities between his part of Illinois and the Ayrshire he had just left. He thought many Scots would take well to owning their own farmland. The rural Midwest was not as well-known as other emigrant destinations but Regan sought to rectify this.

His 1847 "Emigrant's Guide" was one of the most influential books in the history of Scottish emigration to America. Not only was it packed with useful and essential information (especially for farmers) it gave detailed descriptions of the wildlife and landscape of the area. Some of it even reads like poetry.

John Regan always thought the US Midwest had a close affinity with Scotland and praised the region for its "enterprise, activity and resolution". He did much to make Scots feel at home there.

# ALEXANDER SOMERVILLE

*Born. Haddington, East Lothian, 1811.*
*Died. Toronto, Ontario, 1885.*

**"The Whistler at the Plough."**

Somerville was a cowherd and common labourer who enlisted in the Scots Greys to escape poverty. While still a soldier, he wrote a letter to the War Office stating that he and some of the men of his regiment would refuse to fire on the working classes and would refuse to serve in any strike-breaking capacity. Somerville was flogged severely for this but his punishment resulted in a huge public uproar which led to Somerville being awarded compensation. He returned to Scotland to publish his political opinions in the form of letters signed "By One who has whistled at the Plough".

He emigrated to Canada in 1858 where his strong political republicanism gained little sympathy. His writings fell on deaf ears, despite the fact that he praised Canadian democracy, but felt it could be improved. He ended his life in obscurity and was last seen alive begging on the streets of Toronto.

Somerville is completely forgotten now but his own sufferings as a working-class radical in a conservative and class-ridden British Army led to the final abolition of flogging as a routine army punishment; perhaps, that is his true legacy.

# ALEXANDER TROCCHI

*Born. Glasgow, Lanarkshire, 1925.*
*Died. London, England, 1984.*

**Important literary figure, part of the New York "Beat" scene.**

Trocchi was born in Glasgow of a Scottish mother and Scottish-Italian father. He took an Honours degree at Glasgow University and later went to Paris as editor of "Merlin", which published Beckett, Sartre, Henry Miller and others. Trocchi left Paris for America where he worked on the Hudson River "scows" - barges which attracted a notorious variety of writers and artists; the denizens of which were once termed "the lowest form of animal life on the waterfront". At a time when drug dealing could be a capital offence, Trocchi became addicted to heroin and had so much trouble with the New York City police that he had to be hidden and smuggled by bus into Canada, where he was helped by a young Leonard Cohen to board ship for Aberdeen.

Trocchi's New York experiences resulted in his novel, "Cain's Book," published in 1960. It is the diary of a New York junkie and was published first in Britain in 1963, where it sold 20,000 copies immediately. The book was seized by the police and Trocchi was taken to court under the Obscene Publications Act of 1959. The book was banned as obscene in 1964, but the ban was later lifted on appeal.

Trocchi created a sensation at the famous 1962 Writers' Conference at the Edinburgh Festival when he walked out after a shouting match with Hugh MacDiarmid who called Trocchi "cosmopolitan scum".

Trocchi was cosmopolitan in the best sense and his short time spent in New York City and California is part of American "Beat" mythology; Trocchi's influence on young urban writers in America and Scotland has been immense, proving that Scottish influences in North America are not just a thing of long ago.

# JAMES
# GRANT WILSON

*Born. Edinburgh, Midlothian, 1832.*
*Died. New York, 1914.*

**Editor,
author,
soldier.**

Wilson's father was an Edinburgh bookseller who emigrated to upstate New York. Wilson learned his father's business but went to Chicago as an editor and publisher, with little success. The American Civil War intervened, and Wilson proved an outstanding soldier.

Wilson returned to New York to work as editor and biographer - his chief work being the influential *Appleton's Cyclopaedia of American Biography*, in several volumes. He also edited volumes on the lives of US Presidents as well as the history of New York City. James Wilson also became known as a biographer of Ulysses Grant as well as writing on various aspects of literature. He was author of "Poets and Poetry of Scotland from the Earliest to the Present Time" (1876).

Wilson was also in great demand as a public speaker and was involved in various New York City learned societies as biographer, genealogist and ethnographer. He left many valuable papers, photographs and artifacts to the city of New York. He was one of New York City's most notable public figures during his long career in that city.

# WILLIAM WILSON

*Born. Crieff, Perthshire, 1801.*
*Died. Poughkeepsie, New York, 1860.*

**Poet,
bookseller
and
publisher.**

Wilson had no formal education, having begun his working life at age seven as a farmer. He went into the Glasgow cloth trade and became self-educated, reading and attending concerts and lectures whenever work permitted. He had already published many poems and songs by the time he emigrated to New York in 1833, becoming a partner in the famous firm of Paraclete Potter, bookbinders and booksellers. Wilson took over the business and began publishing histories and directories, as well as his own verse.

Wilson popularised a sentimental and nostalgic view of Scotland through poems such as "The Mitherless Wean" which proved popular all over America, with themes of homesickness, patriotism, the simple country life, etc.

Wilson's verse might best be forgotten (or, forgiven) but he did much to carry on that great Scottish tradition of bookselling and publishing in America. His youngest son was James Grant Wilson who learned much from his father and is probably the more influential of the two men who both had a great influence on American taste and letters.

# VII. RICH MAN, POOR MAN, BEGGAR MAN, THIEF

# THOMAS NEILL CREAM

*Born. Glasgow, Lanarkshire, 1850.*
*Died. By hanging, Newgate, London, 1892.*

Was Jack the Ripper a Glaswegian who spent much of his life in a Chicago prison?

**His last words: "I am Jack the ...."**

Preposterous? Maybe. Mass-murderer Thomas Neill Cream was born to a respectable family in Glasgow, who emigrated to Quebec in 1855, where Cream's father became a successful lumber merchant. Cream was a medical student in Montreal and Edinburgh, where he obtained a post-graduate degree in medicine and surgery. Already, this ex-Sunday school teacher had gained a bad reputation for his flamboyance and gambling. Worse than that, he had also become an arsonist, blackmailer and murderer, all behind the facade of respectability. He was forced to flee from Montreal to Chicago, where he was convicted of a strychnine murder. He served a ten year sentence for his involvement in the crime. On release, he sailed to London where he poisoned several prostitutes. He fled to Canada and then back to London, for a final murder spree. He was finally caught, convicted and hanged. Billington, his executioner, claimed Cream's last words were "I am Jack the ....".

Could Cream have been the notorious London murderer? At first glance, no. Cream was supposed to have been in an Illinois prison when the murders took place in London. But some people suspect Cream was a master of cosmetic surgery and actually had a "double" with whom he had entered into an alibi pact. Cream could thus have been in London when the murders took place and his own murders there are in no doubt.

Whether or not Cream was Jack the Ripper, it is certain that Thomas Neill Cream was one Scottish export North America would gladly have done without.

# ROBERT DOLLAR

*Born. Falkirk, Stirlingshire, 1844.*
*Died. San Raphael, California, 1932.*

**From hard work and poverty to owner of major steamship lines. He did much to open up the new Chinese republic to foreign trade.**

Dollar emigrated to Canada with his family, working in various lumber camps until he farmed and bought his own logging business. He went to California and built his own fleet of cargo vessels which moved lumber up and down the California coast. In 1901, he ventured to China and Japan and later built up quite a trade with the Chinese. He urged recognition of the new Chinese Republic in 1912 and was highly feted by the Chinese. Dollar won several contracts to build cargo and steam ships for the Chinese. He also donated money to Chinese charities and agencies. Dollar often displayed a genuine affection for the Chinese people.

In 1923, Dollar was now one of the richest men in America. He and his sons had built up a shipping empire. He began the first ever round-the-world passenger service and was eighty when he first travelled around the globe. Having suffered at the hands of an alcoholic when he was a child, Dollar never drank and never permitted liquor on any of his ships. He died a millionaire, with interests in shipping, lumber, railroads and banks.

His influence is still felt in China. Said one business colleague: "He has done more for our trade with the Orient than any other man alive".

# PETER DONAHUE

*Born. Glasgow, Lanarkshire, 1822.*
*Died. San Francisco, California, 1885.*

**Born to Irish poverty in Glasgow, became one of California's wealthiest citizens.**

From Glasgow to New York to New Jersey to Panama, we finally catch up with Peter Donahue in the California Gold Rush of 1849; failing at the gold, he settled in San Francisco with two of his many brothers. They began to work from a tent, repairing engines and making and repairing other tools and machines for the gold-mining industry. Donahue bought out his brothers and expanded into other areas, including making ironclad ships for the Northern Armies during the American Civil War.

He made the first printing press in California and also built the first steam locomotive seen there. He also branched out into public utilities, including the first gas for street lighting in San Francisco.

He next branched into railways and cable cars and was one of the charter members of the Union Pacific Railway. He gave money to many civic and cultural organisations in San Francisco but steadfastly refused to get involved in politics.

Donahue was described as "one of the most charitable of givers, kindest of benefactors, and most generous of friends".

# WILLIAM DUNBAR

*Born. Near Elgin, Morayshire, 1749.*
*Died. Mississippi, 1810.*

**Planter, scientist, slave owner, naturalist, archaeologist, the first man to observe and explain the elliptical rainbow; discoverer of important fossils.**

Dunbar arrived in America in 1771, setting up as an Indian trader and merchant near Baton Rouge, Louisiana. In 1775, his slaves revolted and three years later, his plantation was plundered during the American Revolution. Recovering from this, his land was next invaded by the Spanish army!

This patient Scot shrugged off these misfortunes in order to manufacture cotton. The money from this enterprise enabled him to buy more scientific instruments. He began to correspond with Thomas Jefferson and was encouraged to survey much of the land about Natchez. He wrote about the unique hot springs in the area, and made a detailed study of native Indian sign languages. He had his own observatory and made special studies of climate and weather, while also making valuable observations on cyclones. He made many important fossil discoveries including that of a woolly mammoth.

His plantation was called "The Forest" and was a centre for learning and scientific study. He had many children; his wife survived him by eleven years. A friend wrote to Thomas Jefferson that "for science, Probity and general information, William Dunbar is the first character in this part of the World.".

# GORDON GORDON

*Born. Scotland, circa 1830.*
*Died. By suicide, Canada, 1874.*

**A mysterious con man. Who was he?**

In the 1870's, America was being carved up into spheres of power and wealth by the great captains of industry who used every means at their disposal to monopolise the wealth of the young nation. Many were monopolists in the fields of oil, steel and land speculation but there is probably no more disgraceful era in American history than that of the "robber barons" and their deeds in the rail industry. Although Jay Gould was no worse than the rest of them, he always had a good instinct for a "bargain". A Scot claiming noble connections offered to help Gould in his power struggles and managed to borrow over a million dollars (a vast fortune in those days) from the railroad magnate.

This well-spoken Scot even supplied Gould with countless names and addresses of "friends" in Scotland and England who would loan Gould money for further expansion. Although "Gordon Gordon" was later arrested for fraud, while his references were being checked, he skipped bail and fled over the border to Canada, where he spent all of the money. He later committed suicide but his true identity was never discovered.

Whoever he was, this canny Scot (and all agree he was Scottish) for a time at least, took on some of America's most shrewd and ruthless men at their own game - fraud - and won.

# GEORGE GRANT

*Born. Rural Banffshire, circa 1810.*
*Died. Kansas, 1878.*

**Grant was a wealthy merchant who founded an extravagant colony - "Little England" - in the wild prairies of Kansas.**

Grant obviously had a nose for business. He became a wealthy silk merchant overnight by cornering the black crepe market when Prince Albert died. This venture gave him enough money to retire, and to realise a dream of his - to found an English colony overseas. For various reasons, he chose the Kansas prairies for his colony, "Victoria".

He built manor houses, shooting lodges and cricket pitches. He imported English birds and wildlife and built wine cellars - all surrounded by English trees and hedges. He advertised in the papers for inhabitants - usually, the castoffs from the English upper classes with time to waste. One observer said Victoria was populated with "playboys, remittance men with allowances, wastrels with money to burn."

On any given day, Grant's colonists could be seen in riding boots and red coats, planning for the day's hunt or evening ball.

Grant's "Little England`" flourished for a time but on Grant's death, soon resorted to being a sleepy Kansas prairie town. Many of Grant's playboy colonists - faced with work and real prairie labour - left quickly for other amusements. Grant's dream didn't survive him by long - his little corner of England on the dry prairie - an odd dream for a country boy from Banffshire in that most Scottish corner of Scotland.

# CAPTAIN WILLIAM KIDD

*Born. Greenock, Renfrewshire, 1648.*
*Died. By hanging, London, England, 1701.*

**The most famous pirate of all time.**

No list of pirates would be complete without the name of Captain Kidd. Strangely enough, Kidd's career as a pirate began when he was sent by the British government, (at the request of the Governor of Massachusetts) to rid the eastern coast of America of pirates preying on vessels bringing supplies to the Colonies. Kidd was empowered to seize any pirate vessels he found. He raised a crew in New York and set off in quest of pirates. On reaching Madagascar, Kidd's career took another turn. Reports began to filter in that Kidd himself had taken to attacking British ships, having become a pirate himself. On finally returning to Boston, Kidd was arrested and accused of piracy. His plea was that he only attacked French ships and that any attacks on English ships were because of mutiny by his own sailors. However, there was an unsolved mystery. Kidd failed to account for a vast fortune that had been given to him to help with his anti-pirate work. Kidd and some of his crew were sent to London for trial; Kidd was also accused of the murder of a crew member named Moore, a charge he admitted, claiming Moore was mutinous and insolent. Kidd was further accused of plundering six ships; he said they were French and thus legitimate targets for a British vessel. Kidd boldly accused the Admiralty of taking his own spoils and dividing it amongst themselves; the very men who were trying Kidd for piracy! Kidd had no legal counsel or advisor and it seems the court was not willing to investigate his claims of irregular behaviour by the officials of Massachusetts who were depriving the British Crown of revenue.

It seems piracy was widespread - merely a matter of national interest - and that Kidd's behaviour was an embarrassment to the more legal pirates of his day - government officials and bribe takers. Kidd's trial was a sham; witnesses may have been bribed and the charges against him were never proven. Kidd and several of his companions were found guilty and hanged at Execution Dock on 23 May, 1701. All his personal effects were forfeited to the Crown and his money was given to charity. The mystery still remains about buried treasure and even now, treasure hunters comb some of the small islands off the New England coast looking for Kidd's treasure.

Kidd's life was an ironic one. He was sent to capture pirates and became a pirate himself, yet it seems his only crime was to do his job all too well. Maybe the real pirates were those government officials who hanged an innocent rogue without benefit of a fair trial.

# ANGUS MCASKILL

*Born. Berneray, Sound of Harris, 1825.*
*Died. Nova Scotia, 1863.*

**"The Cape Breton Giant"**

Angus emigrated with his family to Nova Scotia in 1831. He was a normal-sized child but by the age of 14, he was known locally as the Gille Mor - the big boy. His father had to alter the ceilings and doors to enable Angus to get through. His feats of strength included lifting huge men and throwing them over woodpiles, carrying huge millstones, or pulling the bow from a fishing boat.

Economic depression in the area forced him to go on tour as a type of curiosity - the "Cape Breton Strong Man". Although he was a properly proportioned man and not a circus "freak", McAskill's measurements were as follows: height 7'9", weight 425 pounds (30 stone), 44 inch wide shoulders, boots 17 inches long.

He toured the US, West Indies and Cuba. He won many contests involving challenges to his strength, principally as a lifter of heavy weights. In New Orleans (or New York) he was said to have lifted a ship's anchor weighing 2700 pounds!

McAskill made a small fortune on the road and returned home, setting up a grist mill and salmon fishery. He also ran a general shop suited to his own measurements. He died of "brain fever" in 1863. There is a museum to his memory at the Gaelic College of Celtic Folk Arts at St. Ann's, Cape Breton, Nova Scotia.

He lived most of his life in a district near St. Ann's Harbour in Cape Breton called "Englishtown" because most of its inhabitants "had not the Gaelic" though McAskill's family did. He died there.

# ALEXANDER MCDOUGALL

*Born. Port Ellen, Islay, 1845.*
*Died. Duluth, Minnesota, 1923.*

**A joiner's son from Islay who became a deckhand, then one of the wealthiest inventors in history.**

McDougall's was the classic Highland story. His father was a carpenter and shop keeper who first sought work in Glasgow, then emigrated to Canada. His father was killed in a gristmill accident. Alexander became a farm labourer and blacksmith's apprentice, then ran away to become a deckhand on the Great Lakes at the age of 16. McDougall became a master mariner on these great "Inland Seas" where sudden wintry squalls could sink ships without a trace.

In 1881, he designed the radical freight ship - the "whale back" - which launched his American Steel Barge Company. Later, McDougall developed shipyards in Canada and around the Great Lakes; he founded the city of Everett, Washington. He patented numerous inventions in the shipbuilding industry and designed dredging and grain-loading equipment. He won the largest court settlement in US history - an award of 40 million dollars for an infringement of one of his patents. He helped introduce hydroelectric power to the Upper Midwest where he also invented a peat fuel machine.

This joiner's son died a wealthy man whose inventions had a profound effect on Canadian and American industry.

# MURDO MACKENZIE

*Born. Tain, Ross-shire, 1850.*
*Died. Denver, Colorado, 1939.*

**America's greatest cattleman, tee totalling violin player.**

Murdo Mackenzie left Tain Academy, then later gave up his job as an insurance agent in order to manage the Prairie Cattle Company Ltd, "The Mother of British Cattle Companies" - a cattle empire comprising parts of Colorado, New Mexico and Texas. Mackenzie had to oversee all cattle operations from grazing to marketing and he took up the same post with the Matador Land and Cattle Company Ltd of Dundee - a half million acres of grazing rights in Texas. Mackenzie introduced policies which made his company's beef the best in the world; Mackenzie practised grass conservation methods and was one of the first to make extensive use of barbed wire in order to control herds and thus control feeding and breeding.

He fought with the railroads, attacking corruption and high pricing policies which prompted President Theodore Roosevelt to call him "the most influential of Western cattlemen". Roosevelt appointed him head of the National Conservation Commission. From 1912 to 1918, Mackenzie acquired 10 million acres of pasture land in Brazil, pioneering cattle ranching in that part of South America. Mackenzie served as director of the Denver branch of the Federal Reserve Bank from 1923-1935, when he was eighty years old.

Mackenzie was impressive by all accounts. He never carried a gun on the frontier, unheard of at the time. He permitted no drinking or gambling amongst his employees and had the strength to back up such unpopular policies. Mackenzie refused personal publicity and didn't normally grant interviews. He often fiddled for dances and was a world class fisherman; he was also a fine horseman and had great knowledge of cattle breeding and range conservation. He was a key man in an exciting era of American history.

# ANDREW MACNEILL OF BARRA

*Born. Barra, Outer Hebrides, circa 1750's.*
*Died. Pennsylvania, circa 1820.*

**"Andrew, the honest Hebridean."**

What would it feel like for an 18th century Hebridean to step from his emigrant ship onto the wharf at Philadelphia and see, for the first time, Negroes, Indians, horses, carts and trees? What would it feel like to come to grips with an axe or plough for the first time? Although we can't imagine exactly how it must have been, we do have a fair idea thanks to the writings of a Frenchman, Hector St. John de Crevecoeur.

Crevecoeur was in America at the time and describes the arrival of an emigrant ship from Scotland to Philadelphia. Crevecoeur was fascinated with the new American nation and the people from other lands who were creating it. The Scots he said, "want nothing more than a field to exert themselves in, and are commonly sure of succeeding."

Crevecoeur then traces Andrew's passage from Barra immigrant to prosperous Pennsylvania farmer, with many adventures along the way. Andrew once had to look after his patron's house, when a party of Indians helped themselves to the larder, a common frontier practice at the time. Andrew swore at them in Gaelic (his only language then) and brandished a claymore at them. They in turn made scalping motions at him, which sent Andrew running off at high speed for help. Later, Andrew smoked the peace pipe with them. He later learned to ride a horse, use an axe and plant and grow corn. He worked hard, bought his own land, and with the help of his new neighbours, raised a house and barn.

Although MacNeill is a common surname in Pennsylvania, we don't know if Crevecoeur's "Honest Hebridean" was a real person or not, or just a literary stereotype; certainly, Andrew was based on a real person or persons.

Crevecoeur died in poverty and obscurity in his native France, his wife having been murdered in America while his farm was burned to the ground in the French and Indian wars. His own children may have been sold into slavery; he never knew their fate. We wish Andrew from Barra, whether real or imagined, a happier fate.

# VIII.   SOLDIERS, SAILORS, ADVENTURERS

# THOMAS BLAKE "TAMAS BLAQUE"

*Born. Scotland, circa 1510.*
*Died. Mexico, circa 1560.*

**One of the first Scots to explore North America.**

Spanish exploration in North America (particularly in what is now Mexico) was concerned primarily with the search for gold. The famous Coronado expedition of 1540 sought the legendary "Seven Cities of Cibola" and other mythical places where gold and treasure were thought to abound. Coronado's most famous expedition took 300 soldiers into the hinterlands where they accidentally discovered the Grand Canyon of the Colorado.

It's not surprising that one of Coronado's soldiers was the Scottish mercenary Tam Blake, who had already married a wealthy Spanish lady and was well-established in the New World. Blake had arrived in what is now Mexico sometime around 1534. Blake must have had many adventures along the way and was probably in the small party which first sighted the spectacular Grand Canyon.

We don't know much about Blake or his ultimate fate; we do know he was probably the first Scotsman to seek fortune and adventure in North America.

Millions more would follow in the centuries ahead.

# JAMES CRAIK

*Born. Arbigland, near Dumfries, 1730.*
*Died. Virginia, 1814.*

Craik's father once employed the father of naval hero John Paul Jones as a gardener on his estate. Young Craik studied medicine at Edinburgh University and emigrated to the West Indies, and later, to Virginia. He was surgeon to General Braddock and later became Washington's chief medical officer. Craik was given major responsibility for the establishment of military hospitals throughout the eastern seaboard.

Craik accompanied Washington on a surveying trip into the interior, by horseback and canoe, proving himself a hardy explorer as well as capable field physician.

On his death bed, Washington summoned Craik, who stayed with Washington until his death. Craik left a valuable historical account of Washington's last hours at Mount Vernon, 14 December, 1799. His influence as a physician in America was profound; many young medical students went to Edinburgh University as a result of the respect they had for Craik's own training there.

# ROBERT ERSKINE

*Born. Dunfermline, Fife, 1735.*
*Died. New Jersey, 1780.*

**The map maker who helped win independence for the American Colonies.**

As a young man, Erskine escaped debtors' prison only because he was a likeable chap. His numerous inventions in hydraulics finally enabled him to clear all his debts and he was sent to America to survey the extensive mines near Passaic, New Jersey, for a British firm. Erskine and his young wife arrived in New York in 1771, and Erskine began his work in earnest for the American Iron Company. However, Erskine was entirely sympathetic to the plight of the colonists, and when revolution seemed certain, he began to drill other employees as a militia to fight for George Washington. Washington, himself a surveyor, was so impressed with Erskine's skills as a map-maker that he offered the Scot the position of cartographer and surveyor-general to the revolutionary Continental Army. Erskine was given the near-impossible task of preparing accurate maps for the wilderness west of the Hudson River where many important skirmishes were to take place. His maps became highly prized by frontiersmen and soldiers of both armies. Robert Erskine died in the field, working on yet another map for the cause of American independence. Fortunately, most of Erskine's maps have been preserved and are considered amazing examples of skill and accuracy, given the circumstances under which they were made.

Perhaps more than any military victory in the field, Erskine's maps were the most important factor in American success against the might of the British Army, yet Erskine is still termed the "forgotten general" in American colonial history.

# JAMES GEDDES

*Born. Edinburgh, Midlothian, 1829.*
*Died. Ames, Iowa, 1887.*

**Poet, soldier, teacher of the blind.**

Geddes went to Canada as a youth, then ran away to sea. He served in the British Army in India and the Crimea, as a cavalryman. He settled in Iowa but enlisted in the Union Army when Civil War broke out in 1861. He was wounded at the gruesome Battle of Shiloh; later, he was taken prisoner by the Confederates. He served under Ulysses Grant and General Sherman and was credited with saving the city of Memphis from capture by southern troops. He was also involved in two important victories for the North: Mobile and Spanish Fort.

Geddes returned to Iowa and helped teach in a blind asylum there. He also played an important role in the development of the State College at Ames, Iowa. He wrote poetry, penning several popular songs, some of which are still sung today, including the well-known "Soldier's Prayer".

James Geddes was, above all, a survivor: at sea, in the Crimea, at Shiloh and Spanish Fort. Having survived many harsh battles, he then devoted the rest of his life to teaching those less fortunate than himself.

# EWEN 'CALIFORNIA' GILLIES

*Born. St. Kilda (Hirta), 1825.*
*Died. Canada, circa 1895.*

**World traveller from the world's edge.**

St. Kilda is the most remote of all Scotland's islands and it was into this isolated Gaelic community that Ewen Gillies was born ("Gillies" was the most common surname on St. Kilda). At 26, he emigrated to Australia with his young wife and worked variously as a brick-maker, gold-digger and farmer. Ever restless, he went to New Zealand to dig for gold, leaving his wife and children in Australia until he struck it rich and could send for them. Meanwhile, his wife married another man.

Ewen was off again, this time for America where he was immediately drafted into the Union Army to fight in the American Civil War of the 1860's. He deserted the army and headed for the Californian gold fields where he made a small fortune in six years. He sailed to Australia to gather his children, which his former wife reluctantly allowed him to take back to St. Kilda, in 1871. Gillies was hailed as a type of hero by the locals. He left again, and lived in America for ten years. In 1882, he came back to St. Kilda but the native people there had grown tired of his stories and endless tales about his adventures. He knew he was no longer welcome there so went to Australia with a young St. Kildan woman. However, she grew homesick for her native island. So for the third and last time, he returned to his native place, where he was made even less welcome than before. He took his young wife to Canada, where he died.

California Gillies did leave one souvenir of his world travels - the only metal ring (silver) ever to be seen on the island. Gillies' second wife had handed it over as a keepsake to a friend before she left forever. Traditionally, marriages in St. Kilda had used a woollen thread instead of a proper ring, but Gillies' ring was used in every wedding thereafter. "California" Gillies left a silver ring, having spent so much of his life in pursuit of gold. He was never forgotten on the island, but provided ample proof that one can't truly go home again.

# ALEXANDER HENRY

*Born. Leith, Midlothian, 1837.*
*Died. California, circa 1920.*

**Henry's life: truth stranger than fiction.**

Henry was born in Leith of Shetland parentage. He fought at the Charge of the Light Brigade and met Florence Nightingale while wounded at Sebastopol. 1867 finds him leaving ship at San Francisco. He established a vineyard at Anaheim in southern California, where he also grew oranges and walnuts, while developing his famous fruit brandy. Henry did much to promote wine in California, as well as citrus growing. He built his eccentric house at his ranch - "Caledonia Grove" - in 1905, comprised of a Roman/Egyptian design. It had sculpted gold lions and other statues. There, Henry built his own cannon and fired it on ceremonial occasions. He dressed up in military regalia and generally behaved as an upper-class eccentric.

Proving that old soldiers never truly die, at the age of 80, Henry tried to enlist in the American war effort but was told gently that he was "too young" for the army.

Henry's beloved house was torn down in 1937 to make way for a supermarket but he added greatly to Californian life in a state which always valued its eccentrics - from sunny Leith to sunny California, via the Crimean War.

# JOHN PAUL JONES

*Born. (John Paul) Kirkcudbrightshire, 1747.*
*Died. Paris, France, 1792.*

**"I have not yet begun to fight."**

John Paul Jones' life reads like a penny novel. At the age of 12, he was already serving as a cabin boy and visited his older brother in Virginia. Next, he was a chief mate on a Jamaican slave ship. He later took the helm of a ship on which the captain and first mate had already died of fever. John Paul once flogged a ship's carpenter who later died. Charged with murder, he fled to Jamaica where he killed another man who John Paul accused of mutiny. He changed his name to Jones and fled to America where he obtained a commission in the newly-formed "Continental Navy".

When the American Revolution broke out, Jones captured and destroyed much of the British shipping from Bermuda to Nova Scotia. He even took his raids to Britain and landed in Cumbria. His arrival on the coast of Scotland threw Edinburgh into panic and only a severe storm prevented him landing at Leith. His exploits earned him a gold medal from the American Congress.

In 1788, Jones joined the Russian Navy and was made Rear Admiral. He helped the Russians win many key victories in the Black Sea. He had a disagreement with a superior officer, whom he assaulted. Jones fled to France where he died in obscurity and was buried in the local Protestant cemetery in an unmarked grave. Jones' remains were eventually removed to Annapolis, Maryland, the home of the United States Naval Academy. His grave is now a national shrine in America.

Slaver - pirate - naval hero in both Russia and America - pauper: quite a life for the son of a Kirkcudbrightshire gardener.

# RANALD MACDONALD

*Born. Fort George, Washington State, 1824.*
*Died. Ferry County, Washington State, 1894.*

**Opened Japan up to the West.**

Ranald MacDonald's father was from Argyll; his mother was an Indian named Princess Sunday. He ran away to sea at age 17 and had many adventures before contriving to sneak into Japan which was completely closed to foreigners at that time. He was imprisoned in a bamboo cage but was utilised in teaching English to pro-western diplomats; many of his pupils were instrumental in negotiating the Treaty of 1854 which made trade with Japan possible.

MacDonald had many adventures after that. He dug gold in Australia and arrived in British Columbia during the gold rush of the 1860's. He finally settled on the site of an old trading post at Colville, Washington State. Despite his incredible adventures and his key role in paving the way for America in Japan, he was buried in an unmarked grave in an old Indian cemetery at Kettle River. It was believed he was a victim of racism at the time, thus preventing a political or diplomatic career that might have been his. His life inspired a novel: *McDonald of Oregon,* written in 1906 by E.M. Dye.

# THOMAS MCGREGOR

*Born. Paisley, Renfrewshire, 1837.*
*Died. California, circa 1910.*

**Had a legendary life as a soldier.**

Thomas McGregor from Paisley stood only 5'6" but he was a much bigger man than that. He went to New York as a teenager and ended up panning for gold in California. He joined the US cavalry and served in the American Civil War under Grant and Sherman, where he was wounded twice.

After the war, he went west to fight with the cavalry in numerous Indian wars. He saw active service in Idaho, Arizona, Washington and Oregon, fighting against most tribes. He was made a Brigadier General in 1901 and later saw action in Cuba, the Phillipines and the Boxer Rebellion.

His own exploits against the Indians were legendary. His son, Rob Roy McGregor, became a famous cowboy in the rough Chiricahua Mountains.

Many a Cheyenne and Apache regretted their encounters with this small but spirited Paisley "buddy."

# GEORGE HENRY MACKENZIE

*Born. North Kessock, Ross and Cromarty, 1837.*
*Died. New York City, 1891.*

**"The father of American chess..."**

Mackenzie grew up in Inverness and Aberdeen and worked as a businessman in France, before emigrating to New York City in 1863. On arrival there, he enlisted as a private in the 83rd New York Infantry, fighting with distinction in the American Civil War and captaining an all-negro regiment. On discharge from the army, he took up residence as a professional chess player and writer.

He dominated the chess scene in New York for several years, despite strong competition from the great number of German and Russian emigres in that city. In 1880, he won the American Chess Championships. In all the great international competitions, Mackenzie always managed to place in the prize money; to cap it all, he won the World Chess Championship in Frankfurt, Germany in 1887.

Mackenzie wrote much on chess and helped popularise the sport, becoming one of the few chess professionals there. He would likely have gone on to greater honours had he not died prematurely of pneumonia in New York City.

Despite Mackenzie's success as a warrior and soldier, he was remembered as a fairly genial and easy-going individual who had fought for freedom against slavery. He was well-liked by his negro regiment. Having taught men to fight, he then taught them to play chess. He is virtually forgotten in Scotland; one recent article on chess in Scotland didn't mention him at all, though his skills in the game were obviously nurtured in his native land.

# RANALD SLIDELL MACKENZIE

*Born. New York City, 1840.*
*Died. New York City, 1889.*

**"Bad Hand Mackenzie, scourge of the Comanche."**

Mackenzie was born of Scottish parents in New York City. This was certainly America's good luck, since men like Mackenzie are rare in any country. Mackenzie was trained as an officer and fought for the Union side in some of the bloodiest campaigns of the Civil War, including Manassas, Gettysburg, Spotsylvania and others. He was wounded twice and had several fingers shot off. He helped defend Washington, D.C. against Jubal Early's historic raid. After the War, he was sent to the West Texas "Staked Plains" area and was severely injured in the Indian campaigns there.

Mackenzie was a type of freelance Indian fighter and troubleshooter for the army against the Sioux, Cheyenne and Comanche. He was sent to avenge Custer's defeat by the Northern Cheyenne, and saw action in Wyoming, Colorado, Montana and Utah and later fought the Apache in the Southwest.

Mackenzie was not a racist nor did he consider native peoples inferior in any way. His dealings in war were noble by the standards of the day. He considered himself a professional soldier. He was never reckless, never putting his own men at risk for personal glory - unlike Custer and others. The Indians called him "Bad Hand" because of his war wounds and had universal respect for him.

His health finally failed him due to the many wounds and injuries he had suffered on battle. He died with the rank of Brigadier-General.

Bad Hand Mackenzie was born to Highland parents in New York City but made his own reputation from the Badlands of Dakota to the Rio Grande.

# JAMES FARQUHARSON MACLEOD

*Born. Drynoch, Skye, 1836.*
*Died. Calgary, Alberta, 1894.*

**Had an extra-ordinary career in the Northwest Mounted Police, which he helped found.**

Macleod emigrated to Ontario with his family, who farmed there. Macleod later studied Law, much to the relief of his father who had nearly died from disease in the army and lost seven brothers to fever while serving in India with the British Army. On no account did the elder Macleod want his son becoming a soldier. However, James had other ideas and was eventually offered a commission in the British Army and took part in various skirmishes, including the famous Fenian raids of 1866. He was sent to quell the Metis uprising in Red River; this gave him a taste for military life in the wilderness which affected his subsequent career choice.

In 1873 he was appointed superintendent and commissioner in the newly-formed Mounted Police ("Mounties"). He was kept busy, quelling the liquor trade between lumbermen and Indians and suppressing the notorious American whisky traders operating across the border into Alberta. He established a fort (Fort Macleod) in Alberta. He was an able diplomat with the Blackfeet Tribes in the area, convincing them that he was a man of his word. Macleod set the tone for future dealings with native peoples and was held in great regard by them. Macleod did all he could to achieve better working conditions for his men, who were often ignored by eastern bureaucrats; many times, he had to ride through blizzards to get money or horses for his men. He insisted on the extradition of several Americans who murdered a band of Assiniboine Indians in the notorious

Cypress Hills - the scene of much illegal smuggling and whisky trading. Macleod risked his life to ride into Montana and arrest the men. In 1877, he had an historic meeting with Sitting Bull, who had fled to Canada to avoid American reprisals for his defeat of Custer. Macleod interviewed Sitting Bull and set out Canadian terms; when buffalo began to become scarce, Macleod probably saved the Sioux from certain starvation by bringing them food.

After leaving the Mounties, Macleod served as magistrate and lawyer, demonstrating his skills as a diplomat time and again. He became a judge in Calgary, dying there of Bright's disease.

Macleod's lasting legacy was the belief that native peoples were part of the Canadian mosaic. If Canada's treatment of her native peoples avoided the excesses of her American neighbours, it was due largely to Macleod. It was said his respect for the Indians stemmed from his early days in Ontario where his family made friends with their local Ojibwa neighbours; perhaps it just came naturally to this man from Skye.

He was one of Canada's true heroes.

# JOHN MCTAMMANY

*Born. Glasgow, Lanarkshire, 1845.*
*Died. Connecticut, 1915.*

**Inventor of the perforated music roll, player piano and voting machine.**

McTammany was born into poverty along the Clyde. His sole ambition was to become a concert pianist. McTammany worked in various aspects of ship-building and badly damaged his hands permanently in the rope and chain-making industries. McTammany emigrated in 1863, to Ohio, where he enlisted in the 115th Ohio Volunteer Infantry. He was wounded at the Battle of Chattanooga; while recovering, he began to think about new musical instruments.

When the Civil War ended, he returned to Ohio and taught music, as well as selling pianos and organs. He also continued experimenting with piano mechanisms. He finally perfected a player piano with perforated rolls. He exhibited a model in St.Louis in 1876 that for the first time, successfully incorporated all the features from other inventions. McTammany's player piano stirred up much controversy. Various delays resulted in his patent being copied; he lived in poverty until he could sell a version of a player piano; again, he prospered.

A long and costly litigation reduced him once more to poverty and his own designs were being pirated by many other manufacturers. McTammany also invented the first voting machine which was used in many American state and local elections. Again, his patent idea was copied and pirated, thus beginning another round of litigation. His health broke down and he died on 26 March, 1915. He was buried in Stamford, Connecticut. His remains were later removed to Canton, Ohio.

Appropriately, the music at his funeral was played on a grand player piano. John McTammany is now acknowledged as the true inventor of a workable and practical player piano, despite other people copying his ideas and prospering from them.

# HUGH MERCER

*Born. Aberdeen, 1725.*
*Died. New Jersey, 1777.*

**He wielded two lances: the surgeon's and the soldier's.**

Young Hugh Mercer's career began in a spectacular and tragic fashion: he was a surgeon in the Jacobite Army at Culloden. He fled for his life and arrived in America a year later. From the beginning Mercer established himself as a highly dependable and capable frontier doctor. He took an active part in the French and Indian wars and was said to have escaped many times from hostile troops. He was made commander at Fort Pitt and negotiated treaties with the famous Six Nations Indian tribes. At this time, Mercer made friends with George Washington and moved to Virginia at Washington's insistence. Mercer ran an apothecary shop. When Revolution broke out, he immediately enlisted in the American cause, not an easy thing to do for a man in Mercer's social position. He conducted guerrilla warfare against the British, commanding the famous "Flying Camp", a motley force, famous for its reckless courage and high levels of desertion.

Mercer persisted and was a key figure in the important battle at Trenton, New Jersey. He advised Washington to take Princeton at night - an important victory for the Americans. On the 3rd of January, 1777, his horse was shot out from under him at Stony Bridge and he was surrounded by British troops. Refusing to surrender, he was clubbed to the ground and bayonetted while wounded. His funeral was said to have been attended by over 20,000 people, nearly the population of Philadelphia itself. A monument to his memory is erected in the Laurel Hill Cemetery in that city.

Mercer was thus given a reprieve at Culloden only to be butchered by the same army, thousands of miles away, three decades later. This time, however, his efforts lead to victory and not defeat.

# JOHN PITCAIRN

Born. Dysart, Fife, 1722.
Died. Battle of Bunker Hill, Massachusetts,
1775.

**Immortal-
ised in a
painting of
the first
major battle
of the
American
Revolution.**

Pitcairn's life was an ironic one. He was perhaps the only British officer the people of Boston trusted before the American Revolution and it was Pitcairn they went to with any complaints of military excesses by British troops. They trusted his sense of justice and fair play, yet Pitcairn was one of the first British officers killed when the Colonial troops rose in rebellion.

He was present at the first shots fired during the American Revolution but always maintained that the Americans fired the first shots at Concord Bridge. Pitcairn escaped that battle without injury but failed to convince the local people that British troops meant them no harm.

A famous painting by Trumbull of the Battle of Bunker Hill (Breed's Hill) shows Pitcairn being mortally wounded by a negro named Peter Salem and Pitcairn lives forever in that famous painting. He was interred nearby but his remains were later removed to London.

Pitcairn was well-liked by all who knew him and was an accidental casualty of the Revolution which he did so much to try to prevent by exercising justice and fair play. Pitcairn was certainly in the wrong place at the wrong time, becoming one of the first fatalities in the American fight for independence.

# ARTHUR ST. CLAIR

*Born. Thurso, Caithness, 1736.*
*Died. Pennsylvania, 1818.*

**St. Clair was a major figure in American frontier history.**

St. Clair (Sinclair) was born into a notable Caithness family. He studied at Edinburgh University but soon gave up medicine for soldiering and was sent to Canada in 1760. He soon began farming in Pennsylvania, however, and became involved in colonial governmental intrigues at a time when western Pennsylvania was claimed by the British, the French, numerous Indian tribes and the Commonwealth of Virginia. St. Clair probably managed to avoid an Indian massacre by dealing fairly with the Shawnee and Delaware tribes. He fought valiantly for the American side during the Revolution but his surrender of Fort Ticonderoga made him suspect, although court martial proceedings found him innocent of any wrong-doing. He opposed the American Constitution. Possibly to get him out the way, he was appointed the first Governor of the new Northwest Territory, a post he held from 1787 until 1802. Although St. Clair was canny but fair in his dealings with the Indians of the region, their anger erupted and he was defeated by an Indian Confederacy under Little Turtle at a key battle on the Wabash River. St. Clair was then instructed to build a series of forts - a project which ended in disaster. St. Clair was also distrusted by his men who considered him a poor frontier fighter; furthermore, his second in command, Richard Butler was deemed more knowledgeable about frontier conditions and Indian customs but was seldom consulted by St. Clair, with disastrous results. St. Clair continued to support the wrong causes and his timing in political matters remained inept.

He was removed from office, retiring to his

farm to manufacture stoves, an enterprise which bankrupted him. He died in ignominy and poverty in his old log cabin on Chestnut Ridge, Pennsylvania. He spent the last years of his life writing a defence of his conduct of the Indian wars in the west.

St. Clair seemed one of history's colossal failures; however, he certainly never failed to do the wrong thing at the wrong time. His failures are a great part of American frontier history. On the plus side, he sought fair dealings with the Shawnee and Delaware tribes and probably saved many lives in doing so.

# RICHARD STOBO

*Born. Glasgow, Lanarkshire, 1724.*
*Died. London, England, circa 1785.*

**His
incredible
life inspired
a novel in
which he
appears as
"Occacca-
nastaoga-
rora" which
means,
"nimble as
a weasel"!**

Richard Stobo was the son of a wealthy Glasgow tobacco merchant. He was sent over to Virginia to look after his family business interests. Stobo never prospered so he decided on a military career under the command of George Washington, then in the British Army. Stobo helped design the grim fortress later nicknamed "Fort Necessity". When the French captured the fort, Stobo was taken hostage, which began his real life of adventure. While held captive at Fort Duquesne, Stobo smuggled out a secret plan of the fort, but his letters were intercepted so he was taken by his captors deeper into French Territory, to Quebec. He escaped but was recaptured and sentenced to death. He escaped again and canoed all night, through enemy territory. He reached safety and was awarded money and a captaincy in the British Army as a reward for his sufferings.

He returned to Britain in 1770 and cultivated many important literary and political friends. Stobo might, however, have vanished into the history books had it not been for the Scottish novelist Tobias Smollett, whose novel *Humphrey Clinker* introduces a swashbuckling hero - Lieutenant Lismahago - who is based on Smollett's friend, Richard Stobo. Lismahago is captured, escapes, is recaptured, and is tortured by his Indian captors. Lismahago marries a beautiful squaw - Squinkinacoosta. Lismahago is elected chief of the tribe and this Scots adventurer is renamed "Occacca-nastaogarora" - "nimble as a weasel". Smollett is being tongue-in-cheek here, but all his skills as a novelist probably don't really match the adventures the young tobacco clerk Richard Stobo had in British North America.

# JAMES SWAN

*Born. Fife, 1754.*
*Died. Paris, France, 1831.*

**"Of all the soldiers fighting for the American Revolution, none had a more extra-ordinary career than James Swan."**

Swan emigrated to Boston and might have ended his days as a clerk in a dreary custom house, had the Revolution not intervened. Swan became a revolutionary and took part in the "Boston Tea Party" along with other Scots. Swan later saw action and was wounded at the important battle of Bunker Hill. He helped drive British troops out of Boston Harbour. While Swan's military fame spread, he descended into poverty and bankruptcy. He fled to France, made a fortune there, then returned home as a philanthropist and contributor to many charities. He returned to Europe where he continued to prosper until 1815, when he ended up in prison for 15 years for fraud; oddly, he lived a life of luxury in prison and continued to prosper in his business dealings. He died only a year after being released from prison.

Bank clerk, revolutionary, philanthropist, prisoner - Swan was all these and more. While in Massachusetts, he argued for proper fishing practices in the Massachusetts cod fishing industry; practices now taken for granted. He also publicly attacked the slave trade and stressed his belief that all men were created equal and free, years before this phrase was adopted in the American Declaration of Independence.

Swan's zest for living was so great that fifteen years of prison couldn't dampen it.

# IX.  VISIONARIES

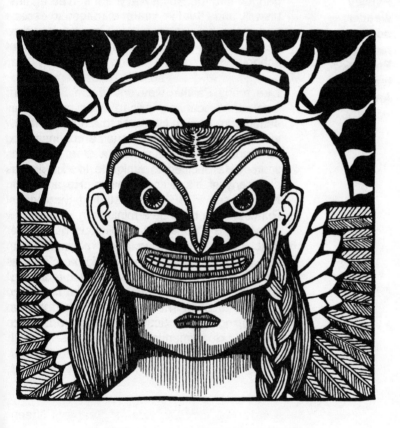

# JOHN BURTT

*Born. Kilmarnock, Ayrshire, 1790.*
*Died. Salem, New Jersey, 1866.*

**Radical Paisley weaver; poet and radical Presbyterian in America.**

As a child, Burtt had scant formal education and was apprenticed to a weaver. While on a routine trip to Greenock, he was kidnapped and press-ganged into the Royal Navy. He served against his will, and after five years, managed to escape and make his way back to Kilmarnock, where he worked as a weaver again. He later taught school.

Like many Paisley weavers of the time, Burtt was a radical republican who made his sentiments known. However, many of his fellow weavers were being imprisoned and transported so Burtt knew his time as a free man was limited. He decided to emigrate to America as did many of his fellow weavers. He arrived in New Jersey in 1817 and studied theology at Princeton. He became a minister in Salem, New Jersey and also edited a religious newspaper which combined his political radicalism with religion. John Burtt also acquired some fame as a poet. His name is virtually unknown today, but it is remarkable that a radical minister having no formal education in his childhood could survive kidnapping and political persecution to become a leading clergyman in America.

# JOHN CLARK

*Born. Petty, Inverness-shire, 1758.*
*Died. St. Louis, Missouri, 1833.*

**Sailor, anti-slavery cam-paigner, travelling preacher.**

John "Father" Clark became a sailor and after a long voyage to America, decided to settle in the backwoods of South Carolina. He next moved to Georgia where he became a Methodist preacher. He visited Scotland but returned to America to become a travelling evangelist, speaking out at every opportunity against slavery, a risky thing to do in the southern backwoods. He refused the annual wage due to him as a minister because of his church's connections with slavery. He soon fell out with the church over the slavery issue and moved to Illinois to become a school teacher.

There, he joined a group called the "Friends of Humanity", which was outspoken in its campaign against slavery in America. Clark took to the road again to promote his anti-slavery views, wandering alone throughout the west and southwest. Many anti-slavery preachers were attacked and murdered, but Clark refused to relent, once travelling over 1200 miles alone on foot through the swamps of Georgia and Florida. He thought nothing of hiking sixty miles a day at the age of seventy to preach his message. He was much loved and respected by all who knew him and was said to "denounce wrong wherever he found it, without regard to church affiliation, general policy or self-interest."

# JOHN ALEXANDER DOWIE

*Born. Edinburgh, Midlothian, 1847.*
*Died. Chicago, Illinois, 1907.*

**The prophet Elijah was born in Edinburgh!**

You probably didn't know the Prophet Elijah was born in Edinburgh. Elijah (real name John A. Dowie) was the son of a tailor turned preacher. Dowie took a temperance pledge at age six, and carried his anti-drink message to Australia, where he became a preacher and faith healer. He sailed to San Francisco and finally came to Chicago, where his career began in earnest. Dowie was a strong orator and enjoyed his role as a charismatic evangelist. He looked the part, sporting a long beard and flowing robes.

By 1901, Dowie was confident enough to declare himself the reincarnation of the Prophet Elijah. He also founded his own "Zion City" forty miles from Chicago. His followers there eschewed tobacco, alcohol, theatres, music, the eating of pork, etc. Dowie owned all the banks and industries in Zion City and his private income (unaudited) soared as a result.

But even bearded prophets must come to grief. Dowie decided to expand his base of operations and hoped to bring the alleged benefits of Zion City to New York City, where he was greeted with scepticism and ridicule. The trip cost Dowie a fortune, which he then tried to recoup from his most zealous followers. He managed to coax more money from them, and set off for Mexico to try his evangelical luck there. Meanwhile, all was not happy in Zion City. When Dowie suffered a stroke, his followers took the opportunity to suspend him from his church and confiscate his properties. Dowie fought them in the courts and was confident of victory, when he died in 1906.

Given our age of Electronic Evangelism, this saga of power and corruption has a surprisingly modern feel to it. Even Elijah, it seems, was not immune from the temptations of wealth and fame.

# DANIEL HOME (DAVID DOUGLAS HOME)

*Born. Edinburgh, Midlothian, 1833.*
*Died. France, 1886.*

**Spiritualist and medium or charlatan and fraud? "Mr. Sludge, the Medium."**

Home was born into a Scottish family which claimed the gift of the "second sight." His real psychic powers developed after being taken to America by an aunt. When he began to hear strange noises, his aunt called in an exorcist, to no avail, and when the loud noises continued, his aunt turned the boy out of the house for good. Home's career continued. He became famous as a medium and was said to be able to levitate. In an age before guitar heroes, Home could play several guitars simultaneously without even touching them; all this while receiving telepathic messages from his mother beyond the grave! He arrived in London in 1856, and began public displays of his powers which brought him the attention of the rich and famous. The Brownings were among those who witnessed his psychic performances. Browning remained sceptical and wrote the satirical poem "Sludge the Medium" as a result.

Home extended his fame and fortune by holding seances in Britain and Europe. He specialised in the tilting of tables and chairs, levitation of heavy objects and the receipt of messages by a type of Morse code of heavy rapping. After an attempt on his life, Home gave up the life of a spiritualist and became a Roman Catholic for a time after an audience with the Pope in Rome. By 1860, Home was at the zenith of his fame and had married into the Russian aristocracy. He continued holding seances and lecturing. His autobiography ran through several editions and brought even more fame and wealth but he was expelled from Rome for alleged sorcery,

followed by a series of lawsuits, contested wills and other scandals. Home always gladly consented to examination by scholars and scientists but never actually took money from his seances.

Home had pop-star status throughout Europe and had far more respect than the average medium of the day. He spent his last years in Switzerland and France. He is buried at St. Germain-en-Laye. Many people testified to his powers of levitation during his life, including many sceptics.

Whatever verdict may have been passed on his abilities as a medium, Hume travelled that rocky road from Scottish orphanhood and homelessness to the courts and drawing rooms of Imperial Europe, with, forgive the pun - great spirit!

# ALEXANDER MACLEOD

*Born. Island of Mull, 1774.*
*Died. New York City, 1833.*

**A great defender of human rights. A minister who preached "a mountain torrent full of foam, but sending off pure water into a thousand pools."**

We think of human and civil rights struggles as features of modern life, but Alexander MacLeod's career over a century and a half ago seems very modern. MacLeod emigrated from Mull to New York in 1792 and immediately became embroiled in controversy by refusing to preach in a church where some of its wealthier members condoned slavery. He continued to preach against slavery before it was safe or fashionable to do so. He had several death threats made against him.

MacLeod's concerns didn't end with the plight of slaves. MacLeod was a pioneer of local history studies in New York City and was a founder of The American Society for Meliorating the Condition of Jews. He was also very involved in the New York Society for the Instruction of the Deaf.

MacLeod is a fine example of a Highlander who would carry the sense of injustice against his own people overseas in order to battle for the rights of other races and nationalities. He didn't court popularity nor did he take the easy route to reform. MacLeod could thus rightly be considered one of the pioneers of the American Civil Rights movement nearly two centuries before Dr. Martin Luther King.

# NORMAN MACLEOD

*Born. Stoer, Assynt, Sutherland, 1780.*
*Died. Waipu, New Zealand, 1866.*

**His followers went with him to Canada, Australia and New Zealand; a charismatic Highland prophet.**

A crofter's son, MacLeod went on to University at Aberdeen and Edinburgh. He taught school in Ullapool, and there built up a loyal religious following in opposition to the local minister causing MacLeod to lose his teaching post at the Church of Scotland school. He had a huge number of followers who shared his criticisms of the established church and its policy of patronage. He took to fishing to pay off his debts, then emigrated to Nova Scotia. Many of his followers went with him. They left Pictou County for St. Ann's where the community finally established itself. Over 700 of his followers settled there.

MacLeod's was a powerful theocracy; he was a magistrate, teacher and Presbyterian minister and received labour on demand from every adult in the community. His goal was nothing less than moral perfection for himself and his followers. However, many believed his power began to go to his head. Nobody was immune from pulpit censure; other ministers in Cape Breton came under fire too. The failure of the potato crop in 1840 prompted another crisis. This charismatic leader persuaded another 800 of his followers to go to Australia with him. Australia was in the middle of a gold rush at the time, prompting another final move to a better moral climate at Waipu, New Zealand.

MacLeod's community prospered there, as they had done in Canada. This crofter's son from Assynt inspired courage and loyalty. He spoke out against many abuses of power in the Scottish Church. His story is the stuff of Hollywood and has inspired many songs and stories.

He is still talked about in his native Assynt; his feats are still recounted in Lochbroom where he lived and preached.

# WILLIAM MACLURE

Born. Ayr, 1763.
Died. Mexico,1840.

**Jack of all trades, master of them all.**

America owes a great deal to William Maclure, scientist, geologist, explorer and educator. Maclure had achieved a fortune in business which gave him much time for scientific study. He became an American citizen in 1803 and spent several years in Europe as a diplomat. On returning to America, Maclure embarked on an ambitious project: to chart and map some of the remaining unexplored regions east of the Mississippi River, a project he undertook alone, at his own expense.

Maclure was also involved in the work of the Philadelphia Academy of Sciences, America's most prestigious scientific organisation of the day. Maclure had an abiding interest in educational reform and utopian communities and was a great admirer of Owen's experiments at New Lanark. Maclure later became interested in Owen's New Harmony experiment, and gave money for the purchase of land and scientific instruments.

Maclure was on board the famous "boat load of knowledge" which brought many leading European scientists down the Ohio River on the way to New Harmony, on the Wabash River in Indiana.

Although the experiment itself was deemed a failure, Maclure's ideas and projects at New Harmony had lasting value. He started the first kindergarten in America, and laid the foundations for lasting work in adult education by founding the famous Working Men's Institutes. Maclure was also credited with beginning the first proper public library in America, and is still considered the first great American geologist. Maclure was a true internationalist and had utopian plans for rural communities in Mexico, when he died.

# RICHARD MELROSE

*Born. Scotland, 1850.*
*Died. California, 1924.*

**He fought for the rights of Japanese immigrants in California.**

Melrose was orphaned at 14 and later emigrated to California. He settled in Anaheim, near what is now Disneyland. He became a local lawyer and politician, serving in the California Assembly.

Japanese immigration into California was a controversial issue at the time. Many Californians argued for strict segregation and didn't believe Japanese should be allowed to own property or vote. Melrose defended the rights of the Japanese, an unpopular position to take.

While visiting Mexico, he was reported as having been killed in a revolution but later turned up alive after a miraculous escape.

Richard Melrose was just one of many Scots who emigrated to America and defended the rights of others who had come there for freedom and equality.

# DAVID
# DALE OWEN

*Born. Near New Lanark, Lanarkshire, 1807.*
*Died. Arkansas, 1860.*

**The Father
of
American
Geology.**

Owen was the third son of the social philanthropist Robert Owen. He went to the Utopian American colony New Harmony but later returned to Europe to resume his geologic and chemical studies. He returned to America and began working as a geologist, accepting the position as state geologist for Indiana in 1837. He next made an extensive survey in Iowa and Wisconsin, being in charge of 139 geologists. It was an extraordinary achievement in the history of geology in America. His career as a geologist saw him promoted to US Geologist and some of his work covered the Badlands of the Upper Missouri. All of his reports included work on the fossils of the areas covered. His illustrations of fossils were considered the finest ever done. His surveys included Wisconsin, Iowa, Minnesota, Nebraska and other territories.

He became State Geologist for Kentucky in 1854 and for Arkansas in 1857, holding the two posts simultaneously! He was also appointed State Geologist for Indiana at roughly the same time but most of the work there was undertaken by his brother Richard.

David Dale Owen combined skills as scientist and administrator that made him sought after by most of the emerging states at the time. His surveys and fossil studies are classics, while all of his scientific works are eagerly sought by historians and antiquarian book collectors.

# ROBERT DALE OWEN

*Born. Glasgow, Lanarkshire, 1801.*
*Died. New York State, 1877.*

**Visionary and practical Utopian.**

Owen was the eldest son of the social reformer Robert Owen, whose New Lanark factory was meant to be a model for the industrial society of the future. Robert Owen was among the many scientists and philosophers in that famous "boatload of knowledge" which took them all to the New Harmony, Indiana settlement where they hoped to carry on the elder Owen's philosophical and political Utopian ideals. New Harmony proved to be a remarkable settlement in many ways, having a profound impact on American life, but was a failure in practical ways. Owen stayed on at New Harmony and edited one of America's first socialist newspapers, along with Dundonian Frances Wright, a pioneer of women's rights.

Meanwhile, Indiana was just beginning its growth and development as a state. Owen was elected to the state legislature and there argued for the rights of blacks, women and other minorities. He also accepted posts in the Federal Government and was instrumental in drafting a letter on which Lincoln's Emancipation Proclamation freeing the slaves was based. Owen was also deeply concerned about the future of freed slaves in America and had views on race relations far ahead of his time.

Late in his life, Owen became more interested in spiritual matters, writing books about supernatural phenomena. He became clinically insane for a short spell, but recovered before he died.

There is no doubt that Owen was a bit of a crackpot. The social experiment at New

Harmony failed for practical reasons; many of its members were impractical intellectuals and scholars who didn't have the necessary frontier skills to survive in the American wilderness. There is also no doubt that Robert Dale Owen's legacy to America was a profound one. He established sound educational practices and achieved much for human rights. Owen's name figures prominently in Indiana history and the state owes much to this Scottish radical intellectual. His name survives on the map of the state.

# JOHN PITCAIRN

*Born. Johnstone, Renfrewshire, 1841.*
*Died. Pennsylvania, 1916.*

**Hard-headed business millionaire and dedicated religious mystic.**

Pitcairn's family moved to the coal-mining and manufacturing region of Allegheny, Pennsylvania where he soon began to work his way up through the railroad business. He later branched into petroleum, becoming one of the first in America to recognise the importance of natural gas. He helped establish the first gas pipeline in America.

His prime business interest was in the plate-glass industry and in 1883 he founded the famous Pittsburgh Plate Glass Company which was incredibly successful. He pioneered many innovations and inventions in the industry including a revolutionary process of slow cooling which is now standard in the making of plate glass.

However, there was another curious side to John Pitcairn. He was a religious mystic and follower of the Swedish mystic Emanuel Swedenborg and helped establish a unique religious community at Bryn Athyn, Pennsylvania. Pitcairn's vision included a church built on the site by a kind of guild system, employing stonemasons, metalworkers, cabinet makers, etc. This project included several ecclesiastical buildings in a magnificent wooded setting. The central building was a 14th century Gothic cathedral.

John Pitcairn was yet another example of the complexity of the Scottish character: he built a gas pipeline while also planning a Gothic cathedral in the American forest.

# JOHN
# SHARP

*Born. Clackmannanshire, 1820.*
*Died. Salt Lake City, Utah, 1891.*

**The Mormon "railroad Bishop".**

Sharp began working in the coal pits at the age of eight. At 27, he became a Mormon and arrived in Salt Lake City, Utah in 1850, where he secured work in a quarry cutting granite to build the Mormon Temple in Salt Lake City. He rose steadily in the Mormon world - in banking, manufacturing and merchandising. His fame, however, rested with his railroad building. He supervised the construction of the ninety miles of the Union Pacific from Echo Canyon to Ogden which featured many remarkable tunnels. He helped develop the Utah Central Railroad, important to the development of Mormonism and to the state of Utah.

John Sharp became famous for more than building railways; because he had three wives, he was tried under the Edmunds Act, forbidding polygamy. It was an important landmark in legal history; he was fined over three hundred dollars then freed, pleading guilty to "unlawful cohabitation".

Although John Sharp was a devout Mormon bishop, he was also a practical man of the world and did much to forge good relations with non-Mormons and to help dispel prejudice against Mormonism. He fathered thirteen children.

Although Sharp was important in Mormon affairs, he was also a key figure in the opening up of railroads in some of the most inhospitable conditions on the North American continent.

# JOHN SWINTON

*Born. Near Edinburgh, Midlothian, 1829.*
*Died. Brooklyn, New York, 1901.*

**Journalist,
social
reformer,
leader in
the Trade
Union
movement,
friend of
Karl Marx.**

Swinton's family emigrated to Montreal, thence to New York City where he trained as a typesetter and journeyman printer. He travelled all over the South and Midwest, settling for a time in Kansas where he argued for Kansas to become an anti-slavery state, despite strong support for a pro-slavery position there. He went back to New York where he worked on the editorial staff of the New York Times; he took an active part in labour demonstrations (some of which were broken up by the police) and ran for mayor of New York City on the socialist ticket, not winning but polling a massive vote.

He joined the New York Sun and continued his radical journalism both with the Sun and with his influential "John Swinton's Paper" - a weekly journal on the trade union movement - in which he pulled no punches and even criticised the trade union hierarchy when necessary. It was boycotted by the mighty "Knights of Labor" movement. He was also a correspondent for several European newspapers.

Swinton was an impressive figure: large head, flowing white hair, skull cap, piercing eyes, powerful oratory. He was also a great friend of Karl Marx. John Swinton always argued for principles of justice, becoming renowned for his honesty and integrity when even the labour movement had its charlatans and self-seekers.

John Swinton was thus firmly in that long tradition of Scottish radicals who enriched other countries.

# JAMES TYTLER

*Born. Brechin, Angus, 1747.*
*Died. Salem, Massachusetts, 1805.*

**"Balloon Tytler", political fugitive, song writer, inventor, editor, eccentric.**

Tytler? Where does one begin? This minister's son dropped out of Edinburgh University to become an apothecary in Leith. He ran up a string of debts because of unsuccessful chemical experiments and took refuge in the famous debtors' sanctuary at Holyrood. From the sanctuary, he edited a number of unsuccessful pamphlets and journals, but also edited and wrote much of the Encyclopaedia Britannica. Tytler was also a manufacturing chemist able to produce pure magnesia nearly forty years before a German chemist was credited with first doing so.

However, Tytler achieved his lasting fame and notoriety in August, 1784, when he became the first Briton to make an ascent in a hot air balloon. His historic flight over Edinburgh took him to a height of 350 feet. On that flight, Tytler had to discard his stove and the balloon crashed in a swamp where Meadowbank Sports Stadium is now located. Tytler was jeered and mocked by the crowds ever after.

The poet Robert Burns pitied Tytler and credited him with composing the famous song "The Muckin o Geordie's Byre" - a song still sung in the folk clubs of today. Tytler, like Burns, was a political republican who didn't hide his sympathies for political change, a dangerous thing to do in the days of Revolution. Tytler was accused of sedition and his trial was set; on that day, however, Tytler was far out in the Atlantic, having fled before the trial. He was then publicly pronounced a "Fugitive from Scottish justice". He turned up in Salem, Massachusetts, where he edited his own paper, *The Salem*

*Register.* He also wrote an important pamphlet on "The Plague and Yellow Fever" which was highly praised by the medical world.

One night in 1805, he was returning home and fell into a clay pit where his body was found the next morning, robbing the young American republic of an able, if eccentric, genius.

It is sad that Tytler's many-sided genius was identified with one comical and short-lived balloon flight over Edinburgh on a summer's day in 1784; a flight which ended with the jeers of the common people in which Tytler had so much faith - a faith which would have seen him imprisoned in his native land; a faith which branded him a fugitive.

# JOHN WITHERSPOON

*Born. Yester Parish, Haddington, East Lothian, 1722.*
*Died. New Jersey, 1794.*

**Theologian, educator, revolution-ary; one of two Scottish signers of the American Declaration of Independence.**

Witherspoon was said to have had even more charisma than George Washington himself. This great leader began his political career in a rather feeble fashion, when he marched with a motley band of students to prevent the takeover of Edinburgh by Bonnie Prince Charlie's troops. His band was easily captured and disarmed, then stuck in the Castle of Doune by some bemused Highlanders. Witherspoon had to escape the unguarded castle by means of a rope made of rags.

The young student later became a kirk minister but was constantly embroiled in religious controversy, resulting in a prosecution for libel and defamation. His fame spread and many nations tried to induce him to their cause. He chose an American offer of Principal of Princeton College, arriving there in 1768. Under his tutelage, Princeton came to rival Yale and Harvard; many important public figures owed their education to Witherspoon at Princeton. His own ideas had a great impact on American theology and education.

His brief scuffle with the Jacobites gave him a new perspective on American moves for independence. He supported revolutionary proposals, thus making himself unpopular with conservative and wealthy American colonial opinion. Witherspoon (who coined the term "Americanism") threw himself wholeheartedly into revolution, arguing all the while for a system of "checks and balances" which became a basis of American political thought. This eloquent Scotsman always seemed to have the right

phrase for the right time. When a colonial orator argued that the colonists were "not yet ripe for independence" Witherspoon replied: "In my opinion sir, we are not only ripe for independence, we are rotting for it."

He was one of two Scottish-born signers of the Declaration of Independence (John Wilson was the other) risking his life in doing so. A blindness shortly before his death didn't halt his public life. He is buried at Princeton and is honoured with a colossal statue in Fairmount Park, Philadelphia.

One wonders if any of those Highlanders who turned a blind eye to the farcical "escape" of the young Edinburgh student would have done so if they knew he would one day turn the political world upside down.

# FANNIE WRIGHT

Born. Dundee, Angus, 1795.
Died. Cincinnati, Ohio, 1852.

**Pioneer in the struggle for women's rights and suffrage.**

Fannie Wright was the daughter of one of Dundee's political radicals who freely risked life and limb to popularise the revolutionary ideas of Thomas Paine in Scotland. Although orphaned when still a child, she managed to educate herself and was writing philosophical works at age 18. She was fascinated with American history and politics, and made a voyage there in 1818, returning in 1824. She then began her lifetime campaign to abolish slavery by settling slaves upon a tract of land she had purchased near Memphis, Tennessee. This experiment was designed to show southern slave owners the way to free their slaves. However, the experiment was considered a failure. Fannie Wright returned to Europe, having freed the slaves on her farm. She next took up residence at New Harmony, Indiana, the experimental Utopian settlement financed by the Owen family of New Lanark. She helped edit America's first socialist newspaper from there and gave public lectures on equality in marriage, the errors of religion, and the evils of slavery and inequality. She was accompanied by an all-female bodyguard to restrain hecklers. She was one of the first to demand the vote for women; as a result, numerous "Fannie Wright" societies sprang up to campaign for universal suffrage.

Her views were in advance of their time. She helped women make political and domestic progress, setting the agenda for future reform. Owen, another Scot who worked with Fannie Wright, regretted that "her courage was not tempered with prudence and her enthusiasm lacked the guiding check of sound judgment." One cynic (male of course) also remarked that she did not have an "excess of humility".

She also made quite an impression on many leading European intellectuals and became a close friend of the more famous Mary Shelley.

# SOME USEFUL SOURCES FOR FURTHER READING

**Appleton's Cyclopaedia of American Biography.** New York: Wilson. (Excellent source for the 18th and 19th centuries. Available in larger reference libraries.)

Black, George Fraser. **Scotland's Mark on America.** New York: 1921.

Brander, Michael. **The Emigrant Scots.** 1982.

Bumstead, J.M. **The Scots in Canada.** 1982.

**Dictionary of American Biography.** New York: Scribner's, 1937. (An excellent source for further reading. Available in larger libraries.)

**Dictionary of Canadian Biography.** 1963.

Donaldson, Gordon. **The Scots Overseas.** Hale, 1966.

**Encyclopaedia Canadiana.** 1957-.

Finley, John H. **The Coming of the Scot.** New York: Scribner's, 1940.

Hewitson, Jim. **Tam Blake and Company: the Story of the Scots in America.** Edinburgh: Canongate, 1993. (The best, most recent book on the subject.)

Hook, Andrew. **Scotland and America.** 1975.

**The Oxford Companion to Canadian History and Literature.**

Reid, W. Stanford. **The Scottish Tradition in Canada.** 1976.

Ross, Peter. **The Scot in America.** 1927.

Most of these books are available in reference departments in larger libraries. Not all are out of print, and some are still available from second-hand booksellers. Most of these books list many more books on the theme of Scottish emigration to Canada and America.

# INDEX